Celebrating Pluralism

Art, Education,
and Cultural Diversity

The Getty Education Institute for the Arts
Occasional Paper Series

●

The Role of Imagery in Learning
Harry S. Broudy

Thoughts on Art Education
Rudolf Arnheim

Art Education and Human Development
Howard Gardner

The Intelligent Eye: Learning to Think by Looking at Art
David N. Perkins

Celebrating Pluralism: Art, Education, and Cultural Diversity
F. Graeme Chalmers

Celebrating Pluralism

Art, Education, and Cultural Diversity

F. GRAEME CHALMERS

University of British Columbia
Vancouver, British Columbia

Occasional Paper 5

The Getty Education Institute for the Arts

The Getty Education Institute for the Arts
Los Angeles, California

Library of Congress Cataloging-in-Publication Data
Chalmers, F. Graeme.
 Celebrating pluralism : art, education, and cultural
 diversity / F. Graeme Chalmers.
 p. cm. — (Occasional paper ; 5)
 ISBN 0-89236-393-2
 1. Art—Study and teaching (Elementary)—United States.
2. Multicultural education—United States. 3. Art—Study
and teaching (Elementary)—Canada. 4. Multicultural
education—Canada. I. Title. II. Series: Occasional paper
(Getty Center for Education in the Arts) ; 5.
N362.C43 1996
372.5'044'0973—dc20 96-8712
 CIP

Table of Contents

List of Illustrations

Foreword

Celebrating Pluralism: Art, Education, and Cultural Diversity comes at a stage in this society's development when wisdom on pluralism in education is sorely needed. Backlash against pluralism either persists or takes on new forms. Debates about cultural heritage continue, extending into educational policy discussions about what students should know and be able to do.

Amidst competing ideas and agendas, Celebrating Pluralism provides a measured attempt to foster understanding. Dr. Graeme Chalmers, professor of art education at the University of British Columbia, Vancouver, promotes the idea that multicultural education can serve as a means of social reconstruction, that it can address persistent forms of racism and prejudice. Yet Dr. Chalmers's ultimate goal is educational. In a progressively more culturally diverse society, it is important, indeed necessary, for young people to have the knowledge, attitudes, and skills of inquiry and interpretation to be able to make their way effectively through such diversity. The achievement of social goals is more likely if a grounding in cross-cultural understanding through education is first established.

Dr. Chalmers, in formulating his educational argument, sets two important premises. Foremost is the view that multicultural education sits squarely within the realm of values and not merely that of facts. To be sure, cultural diversity is a fact, and demographic statistics bear this out. But facts themselves never necessarily imply actions to be undertaken, especially in public policy arenas such as education. Any policy direction must be rooted in a conception of values that informs both means and ends. Celebrating Pluralism recognizes this. Dr. Chalmers, in his opening paragraphs, notes the fact of cultural diversity. He further contends multicultural education cannot be thought of as a technical solution to a problem—rather, that multicultural education can and should be grounded in moral imperatives.

The second premise that guides Dr. Chalmers is his honest admission that the literature of multicultural education and, by implication, its practice, has too often been confused, contradictory, inconsistent, and muddled. Such a characterization would doubtless lead many simply to dismiss multicultural education and its proponents. But Dr. Chalmers recognizes that the ultimate goal of cross-cultural understanding is too important for educators to become easily discouraged by underdeveloped rationales and stereotypical practices. To provide a rationale, Dr. Chalmers carefully, critically, fairly, and, most of all, deeply mined the literature of multicultural education seeking premises for building a basis for multicultural education. His work yielded

an important set of premises that both underlie and pervade statements and arguments throughout *Celebrating Pluralism*:

1. Schooling should be multicultural not only on moral grounds, e.g., that multicultural content is to be included in school curricula on the basis of fairness and justice, but also on educational grounds. Students should see their cultural experiences reflected in the curriculum and develop skills necessary to cross-cultural understanding.

2. Multicultural education is not just for students from ethnic minority cultures, but for all students.

3. Multicultural education should not entail exclusive immersion in the values, outlooks, and depositions of one culture, but the development of knowledge, skills, and attitudes that encourages students to explore a broad diversity of cultural traditions.

4. All modern cultural traditions are multicultural in construction and are changing in content and boundaries.

5. Students' own cultural experiences can be important starting points for learning, but they are not the end points of schooling. Cross-cultural understanding is the primary goal.

6. Multicultural education cannot be achieved by merely adding selected instructional lessons or units to existing school curricula. Change must be holistic and multilayered, entailing revisions in policies, curriculum frameworks, staffing, instructional materials, assessment, and professional development.

7. Multicultural education is not achieved by transmitting inert facts about diverse cultural traditions to students. Learning, while adapted to the styles of individual students, should be borne of students' curiosity, informed by inquiry processes, and centered on challenging content.

8. Processes to institute multicultural education, while complex and multilayered, are indeed manageable.

Celebrating Pluralism effectively draws on and extends key premises in the general literature of multicultural education. In these ways, *Celebrating Pluralism* speaks to broad and diverse audiences. But, needless to say, this volume is also directed to a somewhat more specialized audience as well— arts educators. It sets out and addresses a persistent issue in visual arts education: are discipline-based and multicultural approaches compatible means of organizing instruction in the visual arts? Are such approaches at worst antithetical and, at best, incompatible?

Several elements of the multicultural critique of the comprehensive approach to art education known as discipline-based art education (DBAE) can be identified:

1. There is little place found for the study of the arts of non-Western cultures or community arts in DBAE curricula;

2. The stress on sequential curricula does not encourage sufficient attention to the cultural backgrounds and learning styles of students;

3. This approach limits study of how the creation, dissemination, and use of art can reinforce inequitable social relations in society;

4. DBAE forecloses study that can help students understand objects in their original contexts, appreciate them according to their intended functions or meanings, appraise them using culturally appropriate criteria, or see how the creation and dissemination of diverse forms of art can serve to challenge inequitable socioeconomic relations.

The first element of this critique seems to stem from the perception that DBAE is a specific curriculum. But both theorists and practitioners have long held that discipline-based curricula can take many forms and, further, that the content in such curricula is to be derived from a broad range of the visual arts, including the traditional and contemporary arts of diverse cultures. By the same token, the curriculum can also be effectively adapted to the learning styles of diverse student populations. The third and fourth elements present a stronger challenge—it focuses on the content of DBAE and, ultimately, the role of the art disciplines in curriculum development. It is here that Dr. Chalmers makes a special contribution.

The issues of content cited above focus on the social, historical, thematic, symbolic, metaphoric, and subject-matter aspects of works of art—a central concern of Dr. Chalmers in this volume. Do the disciplines of art identified in DBAE—art production, art history, art criticism, and aesthetics—provide adequate guides to finding meaning in the sociocultural aspects of art? The answer from some critics has clearly been no. Others, in a more constructive mode, have pointed to inquiry processes and concepts from social science disciplines to interpret works from all cultures. (Such issues were explored in the Getty Education Institute for the Arts' third issues seminar, "Cultural Diversity and DBAE.")

But *Celebrating Pluralism* constitutes the strongest argument to date that the four art disciplines are, by themselves, powerful tools and lenses for the interpretation of cross-cultural aspects of works of art. Dr. Chalmers notes how, in theory and practice, DBAE's four foundational disciplines have changed and continue to change. In particular, he demonstrates how they are increasingly defined by related disciplines such as anthropology, sociology, and cultural criticism. For some, this argument may

have provided means for approaching art works from unfamiliar cultures. But Dr. Chalmers offers an additional insight—that the interpretation of all art works, including "masterpieces" of all traditions, is made richer through the lenses of art disciplines informed by sociocultural processes of inquiry. Art education can be a form of social inquiry.

Celebrating Pluralism also effectively addresses a common critique of multicultural education, that it leads to educational experiences for students with no common core and, eventually, to a fractured society with little common ground. Dr. Chalmers stresses that all cultural traditions, including majority or even dominant cultures, can be the object of study in art education. In addition, he makes the case that the sociocultural study of the "why" of art is to be directed not only at differences but at what binds humankind together, at commonalities of experience and vision. *Pluribus* and *unum* need not be incompatible. Indeed, *Celebrating Pluralism* points to a day when talk of forms of art education will not be preceded by qualifying adjectives such as "multicultural" or "discipline-based." All art education, in both theory and practice, will be pluralistic and discipline-based.

The Getty Education Institute for the Arts is grateful to Graeme Chalmers for this contribution and to his many other contributions to the evolution of art education theory and practice. *Celebrating Pluralism* stands squarely within the emerging tradition of Center-sponsored monographs that build bridges between disciplines, modes of inquiry and, ultimately, between theory and practice in art education and general education. The Center invites readers to become fully engaged with the timely and important issues discussed in this volume. We welcome your feedback and your contributions to the continuing dialogue around education in the arts.

David B. Pankratz
Program Officer
The Getty Education Institute for the Arts
(1994–1996)

Acknowledgments

I would like to thank the following people at the Getty Education Institute for the Arts for their encouragement and support: Leilani Lattin Duke, director; Kathy Talley-Jones, manager of publications; and David Pankratz, program officer. Through programs for staff, visits to schools that are trying to meet the needs of culturally diverse students, roundtable discussions, the production of visual materials, and a major seminar with subsequent publications, the Getty Education Institute for the Arts has sought opportunities to discuss how discipline-based art education can effectively embrace and respond to cultural diversity. In sponsoring this occasional paper, the Institute further demonstrates its support for the development of discipline-based art education theory and practice. I particularly thank Karen Hamblen for the many questions and helpful criticisms that she so encouragingly mixed with enthusiasm for this project. For their helpful comments on earlier drafts I also thank Gilbert Clark, Vesta Daniel, David Pankratz, and Harriet Walker. Judy Selhorst helped produce a more readable and carefully referenced volume. My students and colleagues at the University of British Columbia provided an environment conducive to the development of these ideas, and Millie Cumming continues to give very special support. This monograph is for Andrew and his peers.

Cultural Diversity and Art Education

Cultural diversity is fact. Most North Americans live in dynamic, nonstatic combinations of multiple cultures and subcultures. These overlapping groups may be identified by ethnicity, gender, sexual orientation, age, geographic location and mobility, income, occupation, education, and other factors. In this monograph, I will argue that discipline-based approaches to art education[1] that focus on the multicultural roles and functions of art will help all students to find a place for art in their lives and to understand that members of diverse cultural groups have commonly shared needs for art.[2]

For some time, the literature on multicultural education has presented conflicting concepts and promoted conflicting goals, and the definition of *multicultural education* continues to shift. Definitions, programs, and practices associated with multiculturalism and multicultural education have been variously described as confused, contradictory, inconsistent, and muddled (Grant and Sleeter, 1986). Unless art teachers—indeed, all educators who teach art—are presented with reasonable ways to address art in a multicultural society, many may not be prepared to embrace and implement a curriculum that respects pluralism. Whether in schools or in museums and galleries, many art educators already feel that they are being asked to do too much. How, they

ask, can they be expected to teach about all types of art from *all* cultures and *all* time periods?

Critics of extravagant claims for a sociocultural approach suggest that to implement the recommendations of some pluralistically oriented art educators is to get caught up in a "schizophrenic fast lane" (Clark, 1990). Although such criticism may be based in part in the critics' fear of viewing all art and all cultures as equal, and of similarly accepting diverse definitions of quality, to a certain extent these critics are correct. How does one make manageable sense out of a vast diversity of ideas? Clark (1990) asserts that it is "preposterous" to expect teachers to deal with all of the ideas presented and claims made in some multicultural education proposals. He says that he "can't conceive of a teacher who, without dissolving into emotional deterioration, disassociation, and splitting of the personality, could possibly serve all of the diverse masters suggested . . . as 'multicultural education' " (p. 15). In a thoughtful commentary, art educator Peter Smith (1992) has outlined some of the uncomfortable paradoxes in a multicultural approach to art education. He worries that many of the approaches that are being advocated seem more concerned with social issues than with art, and asks, "How shall we choose?" (p. 98). Similarly, in an editorial that appeared in a recent special issue of an art education journal, Daniel and

Manley-Delacruz (1993) state that "multicultural education is prone toward a lack of clarity for learners, supporters, and antagonists" (p. v).

It is possible to implement an approach to art education that respects differences and enhances shared needs, but at present it is difficult for many educators to understand the numerous and complex aims of multicultural and multiethnic approaches to art education. Cultural diversity in art education has been promoted in several different and often ambiguous ways; only a few programs have emphasized commonalities across cultures by showing how art reflects the meanings that cultural groups give to their actions. Often, attempts at multicultural art education have been little more than superficial; for example, students have spent time using school art materials to "copy" art forms from other cultures—the totem-poles-out-of-toilet-rolls approach. My principal aim in this monograph is to bring some order out of the existing chaos. In doing so, I will present some directions for action and respond to one of the most important challenges now facing art education.

Despite the variety of viewpoints expressed in the literature concerning multicultural education, reflecting many competing ideologies, and although the debate will and should continue, art teachers have a job to do, and they need to get on with it. Sara Bullard (1992), editor of *Teaching Tolerance,* cuts through the rhetoric: "We must help our children find a place in our pluralistic world. In doing so we must avoid stereotyping, desegregation, indoctrination, assigning blame. We must confront the problems of prejudice and inequality in our classrooms as well as in our society" (p. 7). This monograph is about such issues, particularly as they apply to teaching art.

My ideas are based upon a few general premises: that cultural pluralism is a reality and that reluctant, grudging, or tacit recognition by one culture of an-other must be replaced by genuine appreciation and proactive corrective action; that no racial, cultural, or national group is inherently superior to another; that no one group's art is basically superior to another's; and that equality of opportunity, in the art classroom and elsewhere, is a right that must be enjoyed by every student regardless of ethnic, cultural, or other differences.

Neil Bissoondath's (1993) novel *The Innocence of Age*, which is about generations and cultures in Toronto, contains the following exchange. Lorraine, one of the principal characters, says:

> *"Differences are easy to find. It's the similarities you really have to dig for."*
>
> *After a moment Pasco said, "Sometimes the differences overwhelm the similarities."*
>
> *"But only if you let them," Lorraine replied. (p. 274)*

In a multicultural society, we sometimes have to dig for similarities. By respecting our differences and by celebrating what we have in common, we who make up this culturally diverse society can hold it together. We may be from different ethnic groups and have different social and economic backgrounds, religions, genders, ages, occupations, sexual orientations, and so on, but in our reasons

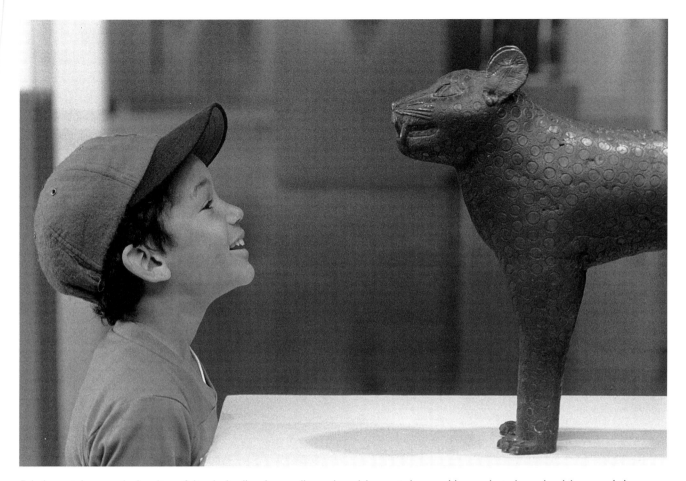

Enjoying art from another's culture. Cultural pluralism is a reality, and grudging or tacit recognition needs to be replaced by appreciation and enthusiastic corrective action. No racial, cultural, or other group is superior, and no one group's art is inherently better than another's. Equality of opportunity, in art education and elsewhere, is a right that must be enjoyed by every student, regardless of ethnic, cultural, or other differences. Photograph courtesy of the Minneapolis Institute of Arts.

for making art, for exhibiting and using art, there is much that unites us.

Why Is Multicultural Art Education Necessary?

In North America and elsewhere in recent years, complete lack of recognition, or only local recognition, of the artistic contributions of many cultures has given way to more active assaults against racism and other forms of prejudice. Attitudes have changed enough so that we have moved beyond simply preserving and enhancing ethnic cultural heritage to fostering positive attitudes and behaviors toward all cultural experiences. Multiculturalism means acknowledging more than just ethnic differences. Differences in gender, religion, sexual orientation, social class, economic status, language, age, and physical ability are also cultural factors to be considered, respected, and celebrated in contemporary curricula (Banks and McGee-Banks, 1989). Multiculturalism, as I use the term in this monograph, acknowledges *all* aspects of cultural diversity. As some writers suggest, the concept of multiculturalism is also a peculiarly Western one, and those who are involved in teaching must approach it with awareness and sensitivity, or it may be perceived as yet another form of cultural imperialism (Collins and Sandell, 1992; Mosquera, 1993). No one can truly know another's culture; listening is more important than telling.

Art educators' concerns with multiculturalism over the past 25 years have been heightened by the release of statistics predicting that by the year 2000, 34 percent of children under the age of 18 in the United States will be black, Hispanic, Asian, or other "minorities" (Schwartz and Exter, 1989; cited in Daniel, 1990). This proportion is expected to rise within another 10 years so that "minority" children will become the majority in the largest states—California, New York, Texas, and Florida. Conversely, by 2010, the proportion of teachers who are members of "minority" groups is predicted to decrease from 1 in 8 in the year 2000 to 1 in 20 (Daniel, 1990; National Education Association, 1989). By the year 2000, approximately 5 billion of the 6 billion people on earth will be nonwhite.

These statistics aside, there are important moral imperatives supporting multicultural art instruction; it should not be viewed simply as a response to a "problem." Multicultural art education provides students with positive ways to deal with art and life under any circumstances. Pankratz (1993) and others who see *multiculturalism* as a normative term caution against assuming that the demographic changes taking place mean that the United States, or any other nation, is increasingly embracing multicultural ideologies. I am encouraged by the attention given to multiculturalism in the recent arts eduction-related reports and draft reports from such organizations as the Consortium of National Arts Education Associations, the International Council of Fine Arts Deans, the National Assessment Governing Board, and the National Board for Professional Teaching Standards. Multiculturalism implies respect for behaviors, dispositions, outlooks, and values that

are not solely from one dominant culture. It is this growing normative view of multiculturalism, particularly in terms of its implications for discipline-based art education, that I will discuss in this monograph.

A multicultural approach is for everyone. *All* students, regardless of ethnicity or other differences, should be prepared to live in an increasingly pluralistic society. As the Canadian government department Multiculturalism Canada (n.d.) states:

> *Canadian children are growing up in a racially and culturally diverse country. Ethnocultural groups within this country are not merely an "integral part"—inferring that some of us have [a cultural] background and some do not; everyone has roots in a cultural group through which one inherits traditions, language, lifestyle and aspirations. Thus, multicultural education is relevant to all racial, linguistic, ethnocultural and regional groups and is designed to engender mutual respect, understanding and harmony between all segments of society. Multicultural education is not just for and about "immigrant children": it concerns and relates to all . . . children. (p. 1)*

Perhaps children who live in culturally homogeneous societies need multicultural education even more than others. Their understanding, appreciation, and respect for cultural diversity and the artistic productions of others need to be expanded, and their possibly limited views of the world need to be challenged. Within the American heartland this has been the approach implemented by Prairie Visions, Nebraska's consortium for discipline-based art

education. One does not have to be female to study women's art. One does not have to live in Miami to examine the art of Cuban Americans, or in Detroit to study the art of African Americans, or in Minneapolis to research the art of the Hmong community, or in Toronto to study aspects of the art of Caribbean Canadians, or in Florence to study the art of the European Renaissance. However, if we are to increase understanding across cultures and minimize cultural conflict, we should take care, if we do live in such areas, to encourage the study of each other's art forms.

PURPOSES OF THIS MONOGRAPH

I believe that it is possible for art educational programs, materials, and activities, and student learning in art to

promote cross-cultural understanding through the identification of similarities (particularly in the roles and functions of art) within and among cultural groups;

recognize, acknowledge, and celebrate racial and cultural diversity in art within our pluralistic society, while also affirming and enhancing pride in each individual's own artistic heritage; and

address through all of the art disciplines (including aesthetics, art criticism, art history, and studio production) issues of ethnocentrism,

bias, stereotyping, prejudice, discrimination, and racism.

In this monograph, I will lead readers through "the interminable debate" (Mogdil, Verma, Kanka, and Mogdil, 1986) within multicultural education in an attempt to help teachers and others consider the functions and roles of art in society in ways that make sense in a culturally diverse society. It is my aim to make theory relevant to practice.

In any search for answers, questions become particularly important. In this chapter I have addressed the question of why art educators should become sensitive to, and aware of, issues of pluralism in art and society. We next need to ask how much commitment and passion teachers need to be able to teach art successfully in a culturally diverse society. What does the effective teacher need to know about the art of cultures other than his or her own? I propose that knowing about the *why* of art across cultures is more important than extensive culture-specific knowledge. A multicultural approach to art education is not simply a matter of including the art of other cultures in the curriculum. Instead, art educators need to understand how art addresses ideas, needs, and values that can be found throughout all times and all places. I will demonstrate that discipline-based art education can provide appropriate lenses through which educators can focus on the common functions of art across cultures.

In Chapter 2, I provide a historical perspective, showing how Western art education has mishandled issues of power and authority in the arts.

Are some art educators' understandings of art still narrowly culture-bound? Do today's art curriculum materials still need to be assessed for their compatibility with viable multicultural education and cross-cultural art theories? To approach art instruction as multicultural, will art educators have to give up the canons of Western art that have long dominated Western art education?

In Chapter 3, I seek to answer a number of related questions: Across cultures, what is art for? Why do all cultures make art? How do different groups of people use art? Are our concepts of art determined by the various groups (cultures and subcultures) to which we belong? What lenses do we need to see commonalities in the functions and roles of art across cultures? How can art educators use cross-cultural and thematic approaches in the teaching of art?

Curriculum issues are explored in Chapters 4 and 5. Using discipline-based art education as a framework, I consider questions such as the following: How can teachers make art education meaningful and relevant for all students, many of whom live in several cultures and subcultures in a diverse and changing world? By focusing on art's common functions, can educators build appreciation for diversity in art? How can questions about art be raised and framed in ways that will promote the discussion of unity within diversity? What themes will encourage students to see what is common in art's roles and functions across cultures? How can art production be an agent for social change? While focusing on the common functions of art, and perhaps encouraging

students to use their own art to envision a better world, how can teachers accommodate the learning styles of diverse populations and unique individuals?

Finally, I suggest some possible answers to the question, How do we begin to implement change? In trying to present some workable solutions to the questions just posed, I have found it wise to avoid the harsh rhetoric that has characterized much of the debate about multicultural education. I give examples of solutions that seem reasonable and implementable—that make manageable sense.

PLURIBUS OR UNUM AND DBAE

Art education takes place within cultural contexts. In a pluralist society, we need to be concerned with the meaning of art for a great variety of people for whom the honored aesthetic exemplars of European male-dominated high art culture may have little meaning. Art educators must address such questions as, How do different cultural experiences influence what individuals and groups perceive as art? Art educators need to do more to encourage the study and practice of art as a social phenomenon. It is not really a matter of either *unum* or *pluribus.* There is unity in art's functions across cultures and diversity in its forms. As Katter (1991) notes, "A broad-based art curriculum integrating the universal, cultural, and individual features of the art experience would hopefully contribute toward . . . the realization that nothing human need be foreign in a multicultural society" (p. 32). Multiculturalism shakes the foundations of education by positing that a highly differentiated society

can hold itself together. However, acknowledging and celebrating diversity requires courage. A multicultural approach challenges both the content and the nature of curriculum, instruction, and assessment. Multicultural content should never be merely an add-on to existing curricula. It should not be addressed superficially—for example, with the inclusion of a few diverse cultural examples in an isolated unit on the decoration of Ndebele houses in southern Africa. Rather, multicultural art instruction should aim to help students understand the functions of art in different cultural contexts as well as understand and appreciate, through art, cultures themselves. True multicultural understanding allows individuals to respond to the properties and qualities that exist in many visual forms across cultures. Through multicultural art education, students acquire knowledge about the contributions artists and art make to cultures and societies and can begin to appreciate how and why people from different cultures value art. Students can deepen their multicultural understanding and appreciation by making art that explores common themes and ideas found in the art of different cultures.

Such multicultural understanding should give art education new life and vigor, because with this understanding, students will increasingly see art as integral to cultural and social life. As the Association for Supervision and Curriculum Development (1992) notes, "The arts are key to understanding every culture"; "it is therefore important that the study of the arts and their history and influence in all cultures be included in every student's education"

(p. 2). Educators who have a multicultural vision see the arts as playing a significant role in the individual and collective lives of all humans, as I will discuss further in Chapter 3.

In a recent *Time* magazine article about a social studies curriculum, Arthur Schlesinger, Jr. (1991) asserted that "in an excess of zeal, well-intentioned people seek to transform our system of education, from a means of creating 'one people' into a means of promoting, celebrating, and perpetuating separate ethnic origins and identities. The balance is shifting from unum to pluribus" (p. 21). Art educators need to respond to such challenges by confronting the concerns that they raise. There is much in art that unites individuals. Although art forms may vary, we all make and use art for rather similar reasons. For example, the poles created by the First Nations peoples of the Pacific Northwest function much as family photograph albums do in other cultures. We all need art, in one form or another, to show us what is real, remembered, dreamed, and imagined.

Although there appears to be universal needs for art (which will be discussed in Chapter 3), we must realize that art is also culturally defined. As Pankratz (1987) has stated, a major goal of multi-cultural arts education

> *should be to provide students with understanding of the principles of appraisal for art works in a variety of different cultures . . . to experience the art works of diverse cultures in ways characteristic of each culture, whether that*

turns out to be aesthetic experience as defined by the Western fine arts tradition, or experiencing the functions that art serves in other cultures through the imaginative reconstruction of the cultural contexts of art works. (p. 69)

In other words, we need to consider the many answers to the following questions:

- How can we define art in a way that makes clear all of its widespread applications?

- What is art in other cultures?

- What is art used for?

- Within different cultural contexts, what constitutes "good art"?

- Who decides these things, by what standards, and for what reasons?

Hilliard (1992) has noted succinctly that "the primary goal of a pluralistic curriculum . . . is to present a truthful and meaningful rendition of the whole human experience" (p. 13). He goes on: "Ultimately if the curriculum is centered in truth, it will be pluralistic, for the simple fact is that human culture is the product of the struggles of all humanity, not the possession of a single ethnic or racial group" (p. 13). Art curricula must reflect both the *pluribus* and the *unum*. Global education programs have the potential to emphasize the commonalities shared by all peo-

ples while at the same time fostering understanding and appreciation of differences within various cultures and subcultures (see Zimmerman, 1990c).

I am not suggesting that teachers completely throw out the dominant canons of Western fine arts. Like Banks (1992) and others, I do not want to exclude Western civilization from the curriculum; rather, I want a more truthful, complex, and diverse version of culture taught in schools, so that Western art is taught in context and, like art from many other cultures, is studied from an anthropological perspective. I want students to realize that art, like any type of knowledge, is socially constructed and reflects the perspectives, experiences, and values of the people and cultures that make it. The chief aims of art education in a multicultural society should be to foster an understanding of art from the perspectives of a variety of cultures, to enhance understanding of other cultures, to demonstrate for students that art is an important part of all human activity, and to promote social change.

I believe that discipline-based art education provides the means for achieving such knowledge and understanding. Although some critics have claimed that DBAE, by narrowly focusing on particular aspects of the disciplines of aesthetics, art criticism, art history, and studio production, is not responsive to the needs of those involved in multicultural art education, others have found these arguments to be "flawed, misdirected, or ill-conceived" (Pankratz, 1992, p. 483). This is not to deny that some DBAE theorists have been less than proactive

in encouraging multicultural approaches to art education. But DBAE is an open concept, not a static, monolithic phenomenon, and there are many factors that affect its continual reshaping (see Wilson, in press). In some DBAE classrooms teachers have responded, sometimes very successfully, to the challenge of multicultural art education. There is growing acknowledgment of cultural diversity, as well as increasing evidence that the art disciplines themselves are in a period of rapid change.

In his report on the six regional DBAE consortia, Wilson (in press) shows that in addition to the content and inquiry processes of art historians, artists, critics, and philosophers of art, DBAE's four disciplines are increasingly defined by related disciplines, such as anthropology, sociology, and cultural criticism. Wilson argues that the art disciplines provide many lenses through which works of art may be created, interpreted, and evaluated. These varied lenses help us find meanings in art objects and events, particularly when they are focused on the social, historical, thematic, symbolic, metaphoric, and subject-matter aspects of works of art—cross-cultural aspects that are essential to my discussion in this monograph. Wilson rejects narrow definitions of DBAE and encourages teachers to employ whatever means might be necessary to infuse the study and creation of art with meaning and substance. Less than a decade ago, McFee (1988) argued that DBAE needed a fifth discipline—"sociocultural art"—but when we consider recent changes in the nature of aesthetics, art criticism, and art history, this no

longer seems necessary. DBAE's four foundational disciplines have changed and continue to change. As Wilson (in press) points out, "There are literally dozens of different lenses for each of the art disciplines." Many of these lenses focus on art in its sociocultural contexts.

By emphasizing functional sociocultural aspects of the visual arts, art education may begin to resemble social science education in some ways. The study of art should illuminate the social context and social impetus for art making and responses to art. Art education may focus on the aesthetic aspects of images and how shape, texture, proportion, design, line, and color are used by different groups, but these elements and principles should be related to the ways aesthetic objects, which often have utilitarian purposes, have been endowed with meaning and "made special" (Dissanayake, 1988), and to how different groups of people respond to that specialness.

Although I advocate an approach to art education that looks for similarities among cultures and that focuses on the common functions and roles of art across cultures, this does not deny the possibility of using art education for social action. The arts have functioned as agents for social reconstruction in a number of cultures, and a multicultural approach that recognizes the power of the arts can be compatible with many of the goals of school reform movements. Problems such as student alienation, boredom, violence, racism, and apathy can and should be addressed through the disciplines of aesthetics, art criticism, art history, and art production.

MULTICULTURAL EDUCATION AS A FIELD OF STUDY: WHAT DOES IT SAY TO ART EDUCATORS?

Art educators who are committed to a multicultural approach are doing many valuable things, but we should also be aware of the major contributions to multicultural education that have been made by scholars outside the field of art education.[3] For example, educator James A. Banks (1989) has provided many insights that have implications for and applications to art education:

A curriculum that . . . largely ignores the experiences, cultures, and histories of other ethnic, racial, cultural, and religious groups has negative consequences for both mainstream [dominant culture] . . . and cultural and ethnic minority students. A mainstream-centric curriculum is one major way in which racism and ethnocentrism are reinforced and perpetuated.

A mainstream-centric curriculum has negative consequences for mainstream students because it reinforces their false sense of superiority, gives them a misleading conception of their relationship with other racial and ethnic groups, and denies them the opportunity to benefit from the knowledge, perspectives, and frames of reference that can be gained from studying and experiencing other cultures and groups. A mainstream-centric curriculum also denies mainstream . . . students the opportunity to view their culture from the perspectives of other cultures and groups. When people [stand

*back from their culture] . . . they are [often]
able to understand their own culture more fully,
to see how it is unique and distinct from other
cultures, and to understand better how it relates
to and interacts with other cultures.*

*A mainstream-centric curriculum nega-
tively influences ethnic minority students. . . .
It marginalizes their experiences and cultures
and does not reflect their dreams, hopes, and
perspectives. . . . Many . . . students are alien-
ated in school in part because they experience
cultural conflict and discontinuities that result
from the cultural differences between their
schooling and community. (pp. 189–190)*

The ideas of writers such as Banks, Gibson
(1976), and Sleeter and Grant (1987) can help us to
understand and position various interpretations of
multicultural art education programs. For example,
like Gibson and Banks, Sleeter and Grant (1987)
examined education literature in an attempt to
understand how previous authors defined *multicul-
tural education*. They identify five meanings of the
term that have applications for art education:

- the teaching of different content to those who
 are not from the dominant culture

- emphasis on human relations, such as
 cooperation and mutual appreciation

- emphasis on single-group studies of particular
 cultures

- emphasis on the promotion of cultural
 pluralism, diversity, and social equity

- emphasis on social reconstruction and
 social action (for example, making art with
 antiracism messages)

The last of these, an optimal consequence, is dis-
cussed further in Chapter 4.

Zimmerman (1990a) undertook research
in this area also, and was able to find some art cur-
riculum materials supporting the first four of these
approaches or positions, although most of the
materials were designed for use in elementary
schools, and some moved little beyond general
advocacy. Roger Tomhave (1992) has also identified
and analyzed different conceptions of art education
in the literature on multiculturalism. Among these,
he found some arguments in favor of the accultura-
tion/assimilation of "minorities" through their intro-
duction to the great works of art of the dominant
culture. Bicultural approaches are also sometimes
favored. In areas with large African American popu-
lations, for example, art education might focus on
both African and European art. Where one group
has enough economic and political power, such as in
the band-controlled schools of some Canadian First
Nations communities, cultural separatism may be
practiced, and the only art taught may be native art.
Socially reconstructive approaches to art education
have mostly been concerned with eliminating Euro-
centrism or sexism from the curriculum. Other

approaches have also been taken, however, such as those concerned with cultural understanding, or with fostering global multicultural perspectives. Clearly, educators have many approaches to choose from as they attempt to meet the challenge of providing multicultural art education. I believe that there are some very positive, nonchaotic ways in which they can respond to this challenge.

CULTURAL RELATIVISM

Throughout this monograph I advocate an approach to art education based in cultural relativism. I am aware of the dangers of this position. Cultural relativism, or the belief in "the co-equality of fundamentally different frames of thought and action characteristic of diverse cultures" (Pankratz, 1993, p. 14), is an unacceptable concept for some critics. Many societies, they point out, condone violence, subjugate women, practice racism, pollute the environment—and these practices should not be valued, no matter what their cultural context. I cannot disagree with this position—in fact, I will suggest that students should make art that is directed against such evils. However, I maintain that we should study the art forms of such cultures within their own cultural contexts, because the study of politics and ideologies is part of the study of art. Rarely is any culture either all bad or all good. In approaching art education, we need to see culture through anthropologists' eyes.

Wasson, Stuhr, and Petrovich-Mwaniki (1990) offer art educators a simple and useful definition of culture: it is a group's ways of perceiving, believing, evaluating, and behaving. These authors note that culture and art have four aspects in common: both are learned through living within a given context and possibly through formal instruction; both are shared by the group; both are adaptive and dynamic; and both may be realigned and renegotiated.

As I have noted above, multiculturalizing art education does not have to mean throwing out Western art canons. Rather, as Rabinow (1986) puts it, "we need to anthropologize the west; show how exotic its constitution of reality has been; emphasize those domains most taken for granted as universal . . . show how their claims to truth are linked to social practices" (p. 241). Hart's (1991) work illustrates this principle. She demonstrates that the Western romantic view of the individual struggling artist, as well as other criteria such as uniqueness, originality, and permanence, cannot be used to assess the quality of all art forms. In some cultures, some kinds of art are intended to be temporary (e.g., sand paintings) and are made by groups of people according to culturally sanctioned conventions. Such works can be evaluated only within their own cultural contexts.

CONCLUSION

It is not only schools that are wrestling with issues of art education and cultural pluralism. As Cembalest (1991) has observed: "As multiculturism becomes the catch phrase of the 90s, [what has been defined as] the art world is doing a lot of soul searching. The trend is to reflect . . . diversity in exhibitions,

[artists], staff, audiences, and, above all, perspective" (p. 104). Now many art worlds are being affirmed.

This occasional paper is intended to help broaden the perspectives of art educators in a variety of public institutions. In it, I seek both to ask significant questions and to provide direction. In the chapters that follow, I will examine past ethno- and egocentric attitudes about art, explore the work of social scientists and other scholars to help increase our understanding of the functions and roles of art in a pluralist society, and seek to make sense of all this to formulate approaches to developing, implementing, and evaluating discipline-based multicultural art education. Because DBAE allows for multifaceted views of art, it offers particularly comprehensive ways to encourage students' understanding of art and culture. The ideas presented in this monograph are based upon my nearly 30 years of work in art education.[4]

Dealing with Our Past:
Ethno- and Egocentrism in the Art Curriculum

Where did some art educators' narrow and elitist understandings of art originate? Prejudiced notions concerning race and gender—for example, that great art has almost exclusively been produced by European males—have conditioned our understanding of art. In this chapter I will examine some origins of these Eurocentric male-dominated notions and theories of rigid social ordering, both biblically and pseudoscientifically based, that have influenced and continue to influence today's approaches to art education.[5]

We in art education are included among those Garcia (1982) describes when he states that all of us have some difficulty discussing racism and prejudice without being defensive, cautious, angry, or timid. As Garcia asserts, we need to set aside fear, anxiety, and timidity and begin to comprehend the causes and results of racism, prejudice, stereotyping, and discrimination, particularly as they affect teaching and learning. The dominance given to Western artistic canons has excluded the art that matters in many people's lives.

Those with power often have used it to distance themselves from various realities and to set up systems that make outsiders of those who are not like the powerful. Even by decontextualizing the study of art and falsely presenting formalist aesthetics as culture-free, those with power have enhanced the status of their own art. In a multicultural society this cannot continue. We must educate students for their multicultural futures.

There can be little doubt that art curricula in North American schools, and some art education scholarship, have been (and continue to be in some areas) dominated by particular notions of good art. Some art educators have charged that these notions are Eurocentric, culture-bound, elitist, and even racist (e.g., Duncum, 1990; Hamblen, 1990; Mullen and Chalmers, 1990; Wasson, Stuhr, and Petrovich-Mwaniki, 1990). Others have also seen them as sexist (e.g., Callen, 1979; Parker and Pollock, 1981). In a recent collection edited by Young (1990), art educators of color speak for themselves and echo such criticisms, as have a number of articles by artists of color (e.g., Pindell, 1990). The effect of biased art curricula on the self-identity of students has been argued eloquently by DePillars (1990), who, paraphrasing Mohandas Gandhi, asserts that the challenge is to develop and implement multicultural curricula that permit "the true winds, not myths, of all cultures to blow freely about in schools without sweeping any students off their feet" (p. 132).

While not denying other forms of injustice and bias, I will argue below that art curricula, and much art educational thinking, have been and continue to be ethnocentric. I will examine some of the origins

of art educators' ethno- and egocentrism. Others, most notably Gould (1981), have pointed out that arguments favoring slavery, colonialism, racial differences, class structures, and sex roles often have been presented and defended under the banner of science. Arguments put forward by craniologists, physiognomists, and geographic determinists, together with those of religious leaders, have been used by various European and North American art educators to promote some kinds of art as more worthy of study than others. By implication, some cultures have been seen as better than others. In the West there has been a tendency to equate great art with the complexity of a culture. Too often, the best in art has been associated with white males, wealth, leisure, and power.

ETHNOCENTRISM

Ethnocentrism is an implicit part of racism. As Le Vine and Campbell (1972) note, *ethnocentrism* has become

> *a familiar word most generally understood, in parallel with "egocentrism," as an attitude or outlook in which values derived from one's own cultural background are applied to other*

cultural contexts where different values are operative. In the most naive form of ethnocentrism, termed "phenomenal absolutism" by Segall, Campbell, and Herskovits (1966), a person unreflectively takes his own culture's values as objective reality and automatically uses them as the context within which [to judge] less familiar objects and events. . . . it does not occur to such a person that there is more than one point of view. At a more complex level is the ethnocentric attitude or outlook that takes account of multiple points of view but regards those of other cultures as incorrect, inferior or immoral. (p. 1)

Sumner (1906) was among the first to define ethnocentrism for modern social science, and we do not have to look too far in the art education literature to find what he calls a "view of things in which one's own group is the center of everything, and all others are scaled and rated with reference to it" (p. 13). For example, recent letters to the editor of *Art Education* written in defense of formalist aesthetics have stated: "If a color relationship is right in New York City, it is just as right in New Guinea" (Lloyd, 1992, p. 7), and "There is a body of knowledge about the elements of art and the language of vision, . . . which is being neglected in favor of the cultural/anthropological focus on multiculturalism" (Lloyd, 1995, p. 5). Another writer has suggested that "the trick in art teaching is to attend seriously to the work of the artist regardless of his/her race, religion, sexuality, blood type or hair color" (Feldman, 1994, p. 8). Each group, Sumner notes, "nourishes its own pride and

vanity, boasts itself superior, exalts its own divinities, and looks with contempt on outsiders" (p. 13).

I should note here that from our present perspective the language used in some of the quotations in this chapter may be offensive. I quote such material verbatim because it can provide some important insight into the origins of continuing prejudice; the historical perspective is a valuable element for current understanding. Thus, I have made no attempt to substitute gender-neutral language or to expurgate possibly offensive terminology when quoting from the works of others.

George Gustavus Zerffi (1876), who taught art history at the National Art Training School in South Kensington, London, and who probably produced the first and most influential text for training nineteenth-century English-speaking art teachers in the discipline of art history, provides an excellent example of European ethnocentrism: "[The] Negro's reasoning faculty is very limited and his imagination slow. He cannot create beauty, for he is indifferent to any ideal conception. He possesses only 75–83½ cubic inches of brain. . . . This [is the] lowest group of mankind" (pp. 23–24). Zerffi calls the Aryan, the white *man*, "the crowning product of the cosmical forces of nature" (p. 26) and, in true ethnocentric fashion, goes on:

To him exclusively we owe art in its highest sense. . . . He surpasses the other . . . groups of humanity, not only in technical skill, but especially in inventive and reasoning power, critical discernment, and purity of artistic taste. The white man alone has produced idealized

master-pieces in sculpture and painting.

The white man in his architecture uses either the horizontal or the vertical line, or both; he takes the triangular building of the Negro and places it on the square tent of the yellow man, making his house as perfect as possible; he goes further, and, in accordance with his powerfully arched brow, over-arches not only rivers and chasms, but builds his magnificent cupolas and pointed arches, the acme of architectural forms. (pp. 26–27)

Zerffi is an interesting example of a racial "hard-liner," but he was not atypical. Ideas like Zerffi's are repugnant in a contemporary multicultural world, but they were common in the artistic and intellectual milieu of educated nineteenth-century society on both sides of the Atlantic. Within the dominant culture such ideas are still influential in shaping some people's attitudes about art. Although I may appear to be judging the past here, my intent is to raise readers' awareness of these lingering influences so that they may assess the validity of such ideas for today's art education. Zerffi's influence was not limited to Great Britain. Copies of his manual and many of his published lectures are available today in some North American libraries.

Although he posits that there were both racial hard-liners and racial soft-liners in the eighteenth and nineteenth centuries, Gould (1981) shows that throughout the supposedly egalitarian periods of both the European Enlightenment and the American Revolution, racial equality was very imperfectly practiced. Such ostensible egalitarianism, which

surfaced again in Hirsch's (1987) recent call for cultural literacy, possibly has its historical source in the condescending "argument that . . . [nonwhite racial] inferiority is purely cultural and that it can be completely eradicated by education to a Caucasian standard" (Gould, 1981, p. 32). Having examined the attitudes of Franklin, Jefferson, and even Lincoln, Gould states, "All American culture heroes embraced racial attitudes that would embarrass [today's] public-school mythmakers" (p. 32).

RACISM

During the European Enlightenment, philosophers generally defined *man* in universalistic terms of mental and psychological characteristics rather than size, skin color, or religious beliefs. However, this did not prevent at least one from pondering:

I am apt to suspect the Negroes and in general all the other species of men (for there are four or five different kinds) to be naturally inferior to Whites. There never was a civilized nation of any other complexion than white, nor even any individual eminent either in action or speculation. No ingenious manufactures amongst them, no arts, no sciences. On the other hand, the most rude and barbarous of the Whites, such as the ancient Germans, the present Tartars, have still something eminent about them, in their valor, form of government, or some other particular. Such a uniform and constant difference could not happen in so many countries and ages, if nature had not made an origi-

nal distinction between these breeds of men. Not to mention our colonies, there are Negro slaves dispersed all over Europe, of which none ever discovered any symptoms of ingenuity, tho' low [white] people, without education, will start up amongst us, and distinguish themselves in every profession. (David Hume, quoted in Popkin, 1973, pp. 245–246)

At this time, Popkin (1973) notes, "the lack of proper intellectual equipment among non-whites became a major basis for judging them in terms of their 'philosophy' and 'way of life' " (p. 248). Linnaeus (1806) is generally credited with being the first to classify the various races, ranging from the animal-like "wildman" through African, American, and Asiatic, to European. Hume's claim that no nonwhites had contributed to civilization or the arts was taken as established fact. Jews and Catholics or Protestants, depending on who was doing the writing, also were suspect, but it was particularly "people of color [who] just did not have the right things going on in their heads to qualify as man in the philosophical sense" (Popkin, 1973, p. 250). The same was often said of women. European males defined the standards. Although overtly stated here, this sort of thinking has long been covertly embedded in hierarchical and gendered distinctions between art and craft and in much of what has been called the elitist aesthetic and art educational theory. The Western study of aesthetics began during the European Enlightenment.

More than 200 years ago, popular books such as *A History of Jamaica* (Long, 1774) introduced European and American readers to such invidious stereotypes of black peoples as "brutish, ignorant, idle, crafty, treacherous, bloody, thievish, mistrustful, and superstitious" (cited in Marsden, 1990, p. 336).[6] How could people characterized in such ways be seen as makers of art?

Although some individuals had less extreme views, they still maintained a definition of *civilization* that was culture-bound, elitist, and patronizing to nonwhites and women. In their view, only the West could claim to be truly civilized, although other cultures were capable of "improvement." In North America this was the view that often found expression in the Eurocentric curriculum of "Indian" residential schools. Similarly, because Europeans saw the Maori of Aotearoa-New Zealand as capable of being "civilized," the New Zealand Education Act of 1914 included special regulations concerning drawing in Maori schools. The following were included as suitably civilized and British objects for study: football, ninepin, carrot, plum, apple, pansy, daffodil, croquet mallet, cricket bat, tennis racquet, school bell, and flower pot (Chalmers, 1990). By omission, this list of objects denigrated Maori culture. Although not as imperialistic, the turn-of-the-century picture study movement in North American schools emphasized the study of European art over art from American cultures.

Nineteenth-century European and North American art education presented child art as inferior to adult art, and the art of "inferior" races was perceived as childlike. Thus, the notion that adults of inferior races are like children of superior races

was supported. In a discussion of recapitulation theory, Gould (1981) quotes Cope (1887) as stating, "We find that the [artistic] efforts of the earliest races of which we have any knowledge were quite similar to those which the untaught hand of [European] infancy traces on its slate or the savage depicts on the rocky faces of cliffs" (p. 153). A leading English psychologist of the time posited:

> In much of this first crude utterance of the aesthetic sense of the child we have points of contact, we have the first manifestations of taste in the race. Delight in bright, glistening things, in gay things, in strong contrasts of color, as well as in certain forms of movement, as that of feathers—the favorite personal adornment— this is known to be characteristic of the savage and gives to his taste in the eyes of civilized man the look of childishness. On the other hand, it is doubtful whether the savage attains to the sentiment of the [white] child for the beauty of flowers. (Sully, 1895, p. 386)

PREJUDICE

Notions of the superiority of some races based on craniometry also influenced thinking in art education. As a National Art Training School instructor in art history, Zerffi (1876) had a considerable impact on art education thinking. His *Manual of the Historical Development of Art* is dedicated to Edwin J. Poynter, the director of the Art Training School at South Kensington. Poynter often referred to classical Greece and Rome and invoked "a tradition of judg-

ments, assumptions, beliefs and norms built up from the Italian Renaissance to the late eighteenth-century" (Pearson, 1982, p. 42; see Poynter and Head, 1885). Zerffi supported this tradition with his craniometric analysis of art in a chapter titled "Ethnology and Its Bearing on Art."

Zerffi was influenced by two prevalent elements in Victorian racial attitudes from at least the 1850s: "the belief in the natural inequality of human beings, and a readiness to generalize freely about the character of racial and ethnic groups" (Lorimer, 1988, p. 428). If, as Marsden (1990) posits, the essence of racism is that it assigns group characteristics to human beings based on physical attributes and assigns these distinctions some sort of social significance that is "emotionally intensified by location in a hierarchical ranking" (p. 333), then Zerffi's views about art certainly were racist. As authors such as Bolt (1971) and Lorimer (1988) show, these views were derived, despite claims to the contrary, not from systematic science but from habits of mind shaped by the sociocultural milieu. We know that much Victorian discussion of race took place in a fairly haphazard fashion. Observations of travelers became mixed with common prejudices. These became embedded in everyday conversation, in stories published by the daily press, in discourse at scientific gatherings, and in scientific publications, including those of the anthropological societies that were founded in London, Paris, Florence, Berlin, Vienna, Moscow, and New York between 1859 and 1870. Certainly prior to 1900, scientific developments failed to counteract the distorting influences

of everyday prejudices, and, in fact, actually served to give these observations both greater coherence and greater authority (Lorimer, 1988).

Besides citing dubious studies about brain size and facial angles, in the spirit of his time, Zerffi (1876) comments that "the Negro" is "slow of temperament, unskilled, his mechanical ingenuity being that of a child; he never goes beyond geometrical ornamentation. . . . He cannot create beauty, for he is indifferent to any ideal conception" (pp. 239–240). Blacks were seen not just to produce inferior art but to be inferior viewers of art, and until well into the twentieth century, African Americans were excluded from many museum audiences. During the 1930s, for example, the Houston Museum of Fine Arts admitted black visitors only one evening per week. This may have been a more generous policy than most, because racial exclusion, tacit or open, characterized most northern arts institutions (Coleman, 1939; cited in DiMaggio and Ostrower, 1990).

Zerffi (1876) comments that in a member of the racial group he labels "Turanian" or "Mongol," the "reasoning faculty is developed only to a certain degree. . . . He excels in technical ability, has great powers of imitation, can produce geometrical ornamentation of the most complicated and ingenious character . . . but has no sense for perspective and no talent for shading. He is incapable of drawing the human form." He continues: "Sculpture of a higher kind is unknown to him, though he can execute perfectly marvelous carvings, which, though quaint in design and composition, are wanting in proportion and expression. . . . Like his facial lines, the roofs of his houses are twisted upwards" (pp. 24–25). Zerffi then praises the art of the white "race" as "the crowning product of the cosmical forces of nature" (p. 26). Zerffi's chapter titled "Ethnology and Its Bearing on Art" concludes:

Though art, undoubtedly, belongs to the magic circle of the imagination, and the inner powers of the mind, those powers are dependent on our very bodily construction, the amount of brain and the facial angle. We do not deal in mere hypothesis, but submit to our readers a complete theory borne out by facts. . . . The Negro fixes our attention only as savage; the yellow man has a line of his own, and has remained stationary in his artistic development; the white man has passed through the savage stages.
(pp. 27–28)

It is not surprising that such statements were common when members of the professional middle class saw a future full of worrisome change and potential decline (Lorimer, 1988). Racism and power were subtly intertwined, as they are still today, and fused to reproduce and normalize oppression that served to maintain the power of a few. Even in some so-called multicultural art education, this heritage has resulted in the continued dominance of Western aesthetic canons, such as formalism, and in the perpetuation of distinctions between art and craft.

Nineteenth-century Christians found support for their belief in a racial hierarchy in the Old Testament, especially chapter 9 of the book of Genesis:

Noah brought out of the Ark three sons, Shem, Ham and Japheth. Ham's son Canaan was

cursed (verse 25) for the offense of seeing his father naked, and condemned to become a servant of servants, i.e., a slave. From the three sons of Noah emerged the races scattered over the earth. The fundamentalist view was that Ham was Black, Japheth White, and Shem in between, representing the Arab [or, in Zerffi's typology, the "yellow"] peoples. It was decreed by God that Japheth's territories should be extended, and that Canaan should be the slave of Japheth and Shem. (Marsden, 1990, p. 334)

Thus, slavery and colonialism were rationalized.

Although it may have been intertwined with economic self-interest, the Victorians had greater respect for Eastern religions than for other non-Christian religions. To Victorians, the notion that Islam could replace Christianity as a civilizing force was, of course, controversial. But that Islam was halfway between barbarism and civilization was probably generally accepted. This idea seems to have been accepted in art education of the time as well. For example, Europeans credited nonwhites, especially Islamic peoples, with doing beautiful decorative and ornamental work, but did not necessarily acknowledge that they could make art. Relying on work available in nineteenth-century British museums and exhibitions, Owen Jones devotes 22 of the 112 plates in his 1856 book *The Grammar of Ornament* to what might be called Islamic design, and 3 to what he terms "savage ornament," although all the examples are from the South Pacific. He also includes 12 plates showing ornament from the Indian subcontinent and 3 showing Chinese ornament. If

his book had been about art, rather than ornament, it is doubtful that the work of nonwhites would have been included. Of the group that he calls "South Pacific Savages," Jones writes patronizingly, "The pleasure we receive in contemplating the rude attempts at ornament of the most savage tribes arises from our appreciation of a difficulty accomplished; we are charmed by the evidence of the intention, and surprised at the simple and ingenious process by which the result is obtained" (p. 14).

Nearly 75 years later, in *The Bases of Design*, art educator Walter Crane (1925) included a 31-page chapter titled "The Racial Influence in Design." Although perhaps assigning some superiority to the Greeks, he acknowledges early Greek art as "differing little in method of treatment and in use of ornament from the Asiatic races, the Assyrian and Egyptian and Persian" (p. 24). However, reflecting a Western bias for representational figurative art, he states that only the Greeks "carried the human figure in sculpture to the greatest pitch of perfection" (p. 204). Despite this view, he presents a generally appreciative account of the "minor" arts of decoration and ornament of most cultural groups. Until very recently, this was the approach taken by many textbooks in the history of art. For example, something similar can be found in Janson's (1981) text *A Basic History of Art*, which its publishers advertised as "introducing the vast world of art at a level students can understand." In this book, South Pacific, Native American, Inuit, and African art are given minimal mention under the title "Primitive Art." South Asian art is not included at all, and in

the basic edition, Chinese art and Japanese art are not mentioned even from a Western ethnocentric viewpoint as influences on Western impressionism, let alone as worthy of study in their own right.

Geographic Determinism

Marsden (1990) has shown that nineteenth-century essayists, poets, and novelists were attracted to hierarchical constructs. Both the "noble savage" and the "lazy native" became stereotypes underpinned by a geographic determinism that regarded the continuum from sloth to vigor as being influenced by climate. Geographic determinism thus provided a convenient defense for racial rankings. "White people were shown to be advantaged by the energy producing climatic variety of the northern temperature latitudes" (Marsden, 1990, p. 337). Leclerc (1785) was among the first to promulgate this theory:

> The most temperate climate lies between the 40th and 50th degrees of latitude, and it produces the most handsome and beautiful men. It is from this climate that the ideas of the genuine color of mankind, and of the various degrees of beauty, ought to be derived. The two extremes are equally remote from truth and from beauty. The civilized countries, situated under this zone, are Georgia, Circassia, the Ukraine, Turkey in Europe, Hungary, the south of Germany, Italy, Switzerland, France, and the northern part of Spain. The natives of these territories are the most handsome and beautiful people in the world. (quoted in Popkin, 1973, p. 251)

Because these "beautiful people" tended to occupy the colder parts of Europe, geographic determinism was used to support claims concerning the superiority of white Protestants. One hundred years after Leclerc, Isaac Edwards Clarke (1885), a nineteenth-century writer on art education, visited Philadelphia's Centennial Exposition: "There came to the thoughtful observer, a sudden revelation of the relative importance, power, and destiny, of the White, English speaking, Protestant races of the earth" (p. 203). He continues: "Certainly if the cognate Germanic peoples are included, no one seeing the Exposition could doubt that the immediate future of civilization rests with the Protestant White races" (p. 204).

Cultural Prejudice and Art Education

To understand the history that has led us to the deeply embedded racism, egocentrism, ethnocentrism, and Eurocentrism we find in art education today, we must be aware of how European explanations of human diversity became increasingly evaluative over the eighteenth and nineteenth centuries. Given this trend, it is not surprising that educators such as Clarke and Zerffi wrote as they did. Europeans and European Americans of their time were very judgmental about anything they found strange. However, this had not always been the case. Writing in the sixteenth century, at the time of the Spanish Conquest, Bartolome de las Casas insisted:

> All the people of the world . . . have understanding and volition, all have the five exterior senses

and the four interior senses, and are moved by the objects of these, all take satisfaction in goodness and feel pleasure with happy and delicious things, all regret and abhor evil. (quoted in Popkin, 1973, p. 247)

This view also was supported by Pope Paul III and others, but opposing positions eventually became predominant. Popkin (1973) posits that because Europeans had given up biblical humanism (the conviction that everyone is made in the image of God), and naturalistic explanations of human nature allowed for normative evaluation, the economics of slavery, colonization, and gold could be justified:

And to nobody's surprise, the theorizers . . . managed to find that people with "wrong," or "inferior" mental properties just happened to have the wrong skin color, or the wrong religious beliefs and practices. In finding this out, the philosophers and natural philosophers were not being aberrational; they were acting as the theoreticians for a major stream of thought that was transforming the universalistic conception of man into a view of the gradations of mankind, a transformation that could justify what was occurring. (p. 254)

These were the dominant views when art was introduced into public schools in North America 125 years ago.

It is not my purpose here to either judge or condemn the past. Rather, I believe that we need to understand the past before we can expose current biased practices and embrace a future that requires art educators to respect and appreciate students' differing cultural backgrounds, values, and traditions; to acknowledge that all groups can produce and define excellent art; and to understand that art exists for rather similar reasons in all cultures. We need art teachers who will nurture a classroom atmosphere in which students' cultures are recognized, shared, and respected. We need art educators who can analyze and pinpoint how and where art education materials are racist and who will develop culturally appropriate curriculum materials to supplement those available when the treatment of different cultural groups is limited or biased. Students can often teach teachers about the arts of their own cultures—in a multicultural society, both learning and teaching need to operate in several directions. We also need to involve parents and other community members in classroom activities, as experts and as resource people. If we are successful in meeting these needs, art education can make an important contribution toward a future in which the humanity of all persons is respected.

Cultural Pluralism as a Concern in Art Education

Since 1951, a few articles on cultural pluralism in art education have been included in the professional publications of the National Art Education Association. Prior to that time, only some minor curricular attention was given to the crafts, usually ceramics and textiles, of other cultures. Stross-Haynes (1993) has documented the antecedent theories, as well as the legislation, that informed some multicultural approaches to art education in the United States

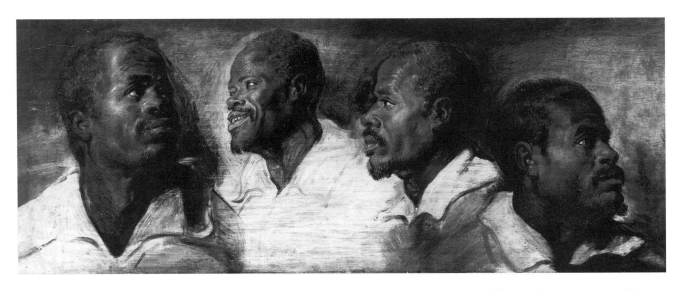

European fascination with the "other." *Four Studies of a Negro's Head*, attributed to Peter Paul Rubens, 1617–40. Oil on wood, 10 × 25½ in. Courtesy of the J. Paul Getty Museum, Malibu, California.

between 1954 and 1980. As an emerging concern in North American art education theory, multicultural-ism can be traced back to the Seminar in Art Educa-tion for Research and Curriculum Development held at Pennsylvania State University in 1965, par-ticularly to June King McFee's (1966) contribution to that seminar, which had its beginnings in her doc-toral dissertation and the subsequent publication of the first edition of her book *Preparation for Art* (1961). This work has been furthered by the anthro-pologically and sociologically based work of others, many of whom have been McFee's students. To a lesser degree, a concern with multiculturalism was also present in Manuel Barkan's (1953) early work and in Viktor Lowenfeld's work at the Hampton

Institute. The increasingly heard voices of nonwhite art educators—brought to our attention particularly with the publication of Eugene Grigsby's *Art and Ethnics* (1977; see also Grigsby, 1991) and more recently by Young (1990) and the National Art Education Association's Affiliate on Minority Con-cerns—have kept multiethnic issues alive. The Na-tional Art Education Association's affiliated Women's Caucus and the Caucus on Social Theory in Art Education have focused on issues of equity, diversity, and multiculturalism. Contributors to Blandy and Congdon's *Art in a Democracy* (1987a) and a few other voices (including, since 1983, the *Journal of Multicultural and Cross-Cultural Research in Art Education*, which aims to "promote a greater under-

standing of diverse cultures and to explore the role of art in multicultural education"; Kantner, 1983, p. 4) have increased our awareness of cultural diversity and its implications for art education.

Despite these developments, however, some art education theorists have been reluctant to relinquish power and authority. They embrace approaches to curriculum and instruction in art that still do not sufficiently question Eurocentrism, elitism, and sexism, prejudices embedded in approaches to teaching that emphasize particular technical skills, formalist aesthetics, working alone as both maker and critic, and even in the dominant choices of media for making art in the classroom. Although, unlike their nineteenth-century counterparts, today's art educators may increasingly see the Western artistic tradition as one of many, the typical reaction to this understanding, in curriculum development and implementation, is still to assign the Western canon major importance and then cautiously add on a few multicultural art examples. Most art educators have not vigorously rethought and revised their approaches to teaching art in an increasingly multicultural and global society.

I want to note here that I use the term *minority* in this monograph only when it has been used in the literature I am discussing. It is a problematic term, used more frequently in the United States than in Canada, to describe persons who are somehow outside of the dominant group. I worry that it can be used not only to acknowledge but also to assign minor importance to groups of people and their art. It becomes too easy for art educators simply to add a unit or two, or to find an additional couple of visuals that picture the art of a so-called minority. Much of art education still relies on sanitized curricula in which art, even when it includes multicultural examples, is bland, pleasant, and middle-class. Rarely have dissent or controversy been fully explored in art education, and rarely have the full implications of cultural diversity, and the unity within that diversity, been implemented in today's approaches to art education.

Conclusion

Shapson (1990) has noted that "attempts to implement new curriculum and innovative teaching for multicultural education are fragile. The efforts of committed educators and other stakeholders stand vulnerable to political pressures" (p. 213). As I have shown in this chapter, art educators are also vulnerable to powerful and ingrained hierarchical constructs about racial and cultural superiority and manifest destiny. It can be argued that art education suffers from what the Cuban artist Flavio Garciandia has called the "Marco Polo syndrome." Often, anything considered different is suspected of being "the carrier of life-threatening viruses rather than nutritional elements" (Mosquera, 1993, p. 35).

Why Do We Make Art? How Do We Use Art? What Is Art For?

In this chapter, I will probe some answers to the questions posed in the chapter title: Why do we make art? How do we use art? What is art for? In a culturally diverse society, it is important that we both ask these sorts of questions and make attempts to answer them, because here we find the unity in pluralism. The broad themes or functions of art across cultures should become the focus for effective multicultural curriculum development in art.

FINDING SOME UNITY IN DIVERSITY

In Western culture, the word *art* itself suggests many meanings. It can be used to refer selectively to particular works—such as paintings, symphonies, sculptures, novels, dance pieces, films, or plays—or it can be used to describe a process. It can also be used in an evaluative sense, to qualify a work or artifact in a particular way (as in "Now that's art!"). Mann (1977) suggests that there are a series of questions that we continue to ask about art:

- What is art?

- What is it for?

- What constitutes good art?

- Who decides these things?

- By what standards?

We need to ask these questions and seek answers to them in ways that acknowledge cultural diversity, because existing answers to questions about art usually are culture-bound. Even our use of a word like *art* is culture-bound. In a multicultural context, as Dissanayake (1988) notes, "in many cases categories are better approached by considering how they function rather than what they objectively are" (pp. 58–59). She points out that, "like many questions no one bothers to ask, 'What is art for?' only shows its intriguing possibilities when one starts prodding it about" (p. 3).

Although a number of anthropologists working in a variety of cultural settings have asked what art is for, students who are taught art in schools and museums, and the teachers who teach these students, rarely ask this question. Working as anthropologists, and using cultural informants, students can identify the art forms that matter in a variety of cultures and subcultures, discuss the functions and roles of those art forms, and understand how, why, and by whom excellence is defined. Cultures can be big or small. They can overlap, and within a domi-

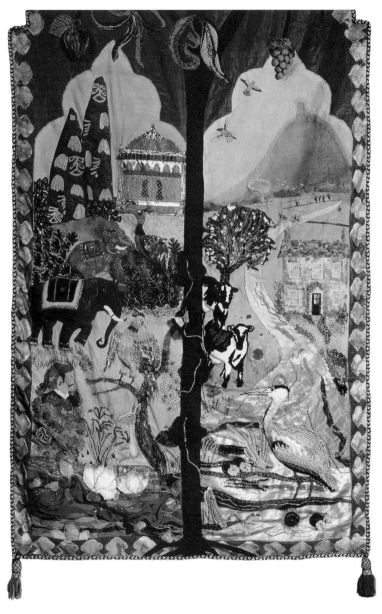

Two Landscapes (India and Somerset, England), tent hanging, Ansford Women's Group and Ansford Community School, Nehru Gallery National Textile Project, 1993. Fabric and stitchery, 10 × 4 ft. Courtesy of the Victoria and Albert Museum, London, England.

Inspired by a museum collection and using South Asian women and a museum educator as cultural informants, British schoolchildren, together with local South Asian women, made this embroidered and decorated tent hanging. The combination of Mughal and Somerset imagery is decidedly multicultural. The members of the Ansford Women's Group reclaimed part of their own history. The Ansford Community School students were introduced to South Asian culture and learned that art can be produced with a variety of materials and by cohesive and cooperative groups, not just by talented individuals working alone.

nant culture people can belong to several groups or subcultures. It is within these local subcultures that students might begin to identify art that matters and discuss its functions and roles. Subcultures may be defined according to various characteristics, such as ethnicity, age, gender, occupation, and education.

Social science literature and some of the new literature in aesthetics (Anderson, 1990; Blau, 1988; Dissanayake, 1992) tells us that all groups need and use art for purposes of identity, continuity, and change and to enhance their cultural values, and that art exists across cultures for gnoseological (functioning to give a knowledge of the spiritual), hedonistic, and recreational purposes (Karbusicky, 1968). Although they are gaining currency in art literature, such cross-cultural concepts as art in the service of religion, art for social status, art for social change, and art as aesthetic enhancement have not been sufficiently translated into curriculum and instruction in art. Art educators have done a better job of equating art with recreation, and unfortunately, this perspective has remained dominant.

It is important that we increase our knowledge about the variety, place, and role of art in social life if we wish to increase intercultural understanding, because in art's diversity we can see some common functions. In a variety of memorial and religious artworks we can find images that perpetuate cultural values. In political cartoons, *arpilleras* stitched by South American women, and some gallery-based performance pieces, cultural values may be questioned. In the designs of clothing, environments, and objects, embellishing and "making special" are

cross-cultural phenomena. If we are truly interested in multicultural education and understanding, we must study the arts as social institutions influencing and being influenced by the cultures and subcultures of which they are a part. We do not pay enough attention to the *why* of art, and our own culture-bound aesthetic preferences restrict the universality of our approaches to the study of art. We need to move beyond our own preferences.

Adrian Gerbrands (1957), a Dutch anthropologist who has worked extensively in Africa, asserts that the arts are essential for three reasons: to perpetuate, change, and enhance culture. He has shown that the arts reinforce and pass on cultural values and that they transmit, sustain, and change culture as well as decorate and enhance the environment. Gerbrands has shown that the arts, directly and indirectly, may bolster the morale of groups, creating unity and social solidarity (e.g., public sculpture; uniforms, crests, and insignia; symbols in printed and woven textiles), and also may create awareness of social issues and lead to social change (e.g., the AIDS Memorial Quilt; Judy Chicago's *Dinner Party*). A connection to the arts may serve as an indicator of social position, and some forms of art may be considered commodities that can increase the power and prestige of the participant or owner (architecture, jewelry, portraits, and so on).

Across cultures, the arts may be used to express and reflect religious, political, economic, and other aspects of culture. At various times, artists, because of the impact of their work, have been identified as magicians, teachers, mythmakers, socio-

therapists, interpreters, enhancers and decorators, ascribers of status, propagandists, and catalysts of social change. The visual images created by people we call artists make it possible for us to learn about and understand cultures, their histories and values. Sometimes artists ask us to question certain values. Sometimes they encourage us to imagine and dream. Across cultures, by making things special, artists both delight our aesthetic senses and provide objects with many sociocultural functions. As we develop multicultural art education curricula, we need to show these aspects of art to students. Rather than expose them only to techniques and materials by having them copy art forms found in other cultures, or engage them in contextless aesthetic discussions in which what art looks like is considered more important than what it means, art educators should show their students that there is no culture without some form of internally valid artistic expression.

If art making and performing are media for "the doing, the making and the living of a culture" (Archer, 1978, p. 12), it is reasonable to assume that *cultural understanding* could be one of the most important reasons for learning about the arts. As I have noted previously, culture may be described as a people's ways of perceiving, believing, evaluating, and behaving. Students, who actually live in multiple cultures, need to understand how aspects of culture can be visually present in memorial art, personal and environmental decoration, political and protest art, and religious art.

A pluralist, multicultural, discipline-based perspective and approach should help art educators realize that there are many different types of art that cannot be divorced from their cultural contexts. We need to embrace broad contextual definitions. Toni Flores Fratto (1978), a social scientist who has written extensively on the arts, states bluntly:

> *The fact is, there is no such thing as art. That is, there is no such thing as art in itself. Art in itself is not a universal human phenomenon, but a synthetic Western category, and a relatively recent one at that. The concept has generated endlessly misleading ethnography, art history and esthetic theory, and has acted mainly to mystify the social conditions which keep acts of creation and sensual pleasure out of the experience of the socially exploited majority. (pp. 135–136)*

It will be useful, then, to see what social scientists have said about what we loosely call art. Students need to understand the values that lead different individuals and groups of people in diverse societies to create, acquire, protect, commission, display, admire, steal, destroy, become advocates for, and ignore art.

What Do Social Scientists Say about the Why of Art?

The ways in which anthropologists and sociologists study art have only recently been embraced by aestheticians, art historians, and critics. Sociologist Judith Blau (1988) suggests that sociologists of art tend to focus their attention on the material and social conditions and functions of art. This, she

notes, "has resulted in a considerable advance in our understanding of the 'peopled' arrangements that help to define the matrix of art production and consumption" (p. 269). We in art education need to make use of such work, because we cannot really understand art without including such perspectives or lenses from the great variety of individuals and groups across cultures who make art, preserve it, sell it, collect it, steal it, study it, use it, and enjoy it. Despite the respectability given by philosopher-aesthetician Arthur Danto's (1981) work on art as a social designation, Blau (1988) suggests that it may still be heretical for a sociologist to make a statement such as "Art is what an institution defines as art" (p. 270). However, it must be done: art is what a culture says it is. For art education, such a view is useful and important because it challenges what Blau (1988) calls "the traditional and tenacious Kantian assumption [discussed in Chapter 2] that ideas and aesthetic values are pure and recondite" (p. 270) and the belief that what one culture calls art will be recognized as art elsewhere.

In her important book *The Social Production of Art*, Janet Wolff (1981) argues that "film, literature, painting and rock music can all, in some sense, be seen as repositories of cultural meaning, or, as it is sometimes put, systems of signification" (p. 4). Artistic creativity, she states, is not different in any relevant way from other forms of creative action. Wolff posits that an individual artist "plays much less of a part in the production of the work than our . . . view of the artist as a genius, working with divine inspiration, leads us to believe" (p. 25). She argues that

many people are involved in the production of any work of art, that sociological and ideological factors determine or affect the artist's work, and that audiences and "readers" are all active participants in creating the finished product. Vasquez (1973) has written that to deny that the artist is subject to the tastes, preferences, ideas, and aesthetic notions of those who influence the market is absolute twaddle. Art educators must help students to see that art encodes values and ideologies. Likewise, how art is discussed and interpreted "is never innocent of the political and ideological processes in which the discourse has been constituted" (Wolff, 1981, p. 143). Aesthetic enjoyment and aesthetic experience are also socially grounded.

The notion that most artists produce their works within a matrix of shared understandings and understood purposes has considerable sociological support (e.g., Becker, 1976, 1982; Dubin, 1986; Fine, 1977; Kadushin, 1976). It is the job of art educators to help students investigate those understandings and purposes. Art education should reflect the attention paid by sociologists to the socialization of artists, how artists acquire artistic identities in different societies, and the relation of artists to many different types of publics and patrons. Becker (1976, 1982) asserts that art involves all those people and organizations whose activities are necessary to produce the kinds of events and objects that a particular group defines as art. This includes people who might conceive the idea of the work (patrons and special interest groups as well as artists), people who execute it (either individuals or groups), people who

provide necessary equipment and materials (donors, manufacturers, technical experts, community representatives), and people who make up the audience for the work (including critics, aestheticians, and, later, historians). Becker argues, as do an increasing number of art historians and other scholars, that it is sociologically sensible and useful to see art as the joint creation of all these people. Who are the artists, the facilitators, and the audiences in different cultures and subcultures? The cross-cultural similarities in the roles of artists, patrons, and publics need to be studied. For example, the cultural context in which a new pole is commissioned, executed, and raised in an Alaskan First Nations community might be compared with a story of the creation and reception of an altarpiece in medieval Europe, or with the erection of a contemporary public sculpture in a large city.

The owning of art can have a special correlation to social status. For example, Berger (1972) has shown that from the Renaissance, a relationship has existed between European oil painting and property, inasmuch as the possession, size, subject matter, and display of paintings often constitutes a visible sign of wealth and status. Bourdieu (1980/1984), who studied the use of art as a form of cultural capital, concludes that art-related cultural participation provides individuals with increased power and prestige. His claims have been supported by studies in non-Western societies (e.g., Gerbrands, 1957), where social status has been, as in Western culture, related to art consumption and participation.

Art is used both to perpetuate and to change cultural values. Lukacs (1971), Balfe and Wyszomirski (1985), and Dubin (1986) have studied the role of art in cultural imperialism as well as in cultural change; their work has many implications for multicultural approaches to art education, and these are discussed in Chapter 4.

In addition to anthropology and sociology, Blau (1988) notes, the lenses provided by cultural semiotics and linguistics are relevant to the study of art, particularly in complex multicultural postmodern societies. Such lenses provide alternative ways for students of the arts to begin to examine how meanings are constructed at the broad societal level and at local levels (e.g., How is art talked about in the everyday language of various groups?), and how these meanings are related to institutionalized practices. A multicultural approach to art education requires that art educators use a variety of lenses to look carefully at the many ways in which art is viewed, discussed, understood, and valued.

What Is Art For? Three Approaches

In this section, I present three approaches to the issue of what art is for. Each has particular implications for the ways in which art should be taught in a multicultural society, and each provides opportunities for finding some unity in diversity. All three approaches promote a view of art as a powerful, pervasive force that helps to shape our attitudes, beliefs, values, and behaviors.

Dissanayake (1984) identifies eight general and cross-cultural functions served or manifested by art.

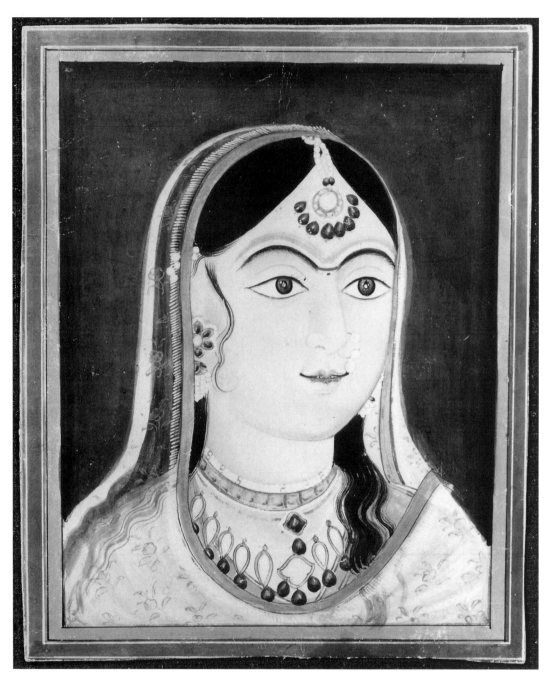

Rajput Lady, artist unknown, Northern India, late nineteenth century. Painted paper, 9¹/₄ × 7¹/₂ in. Courtesy of the Girard Foundation Collection in the Museum of International Folk Art, a unit of the Museum of New Mexico.

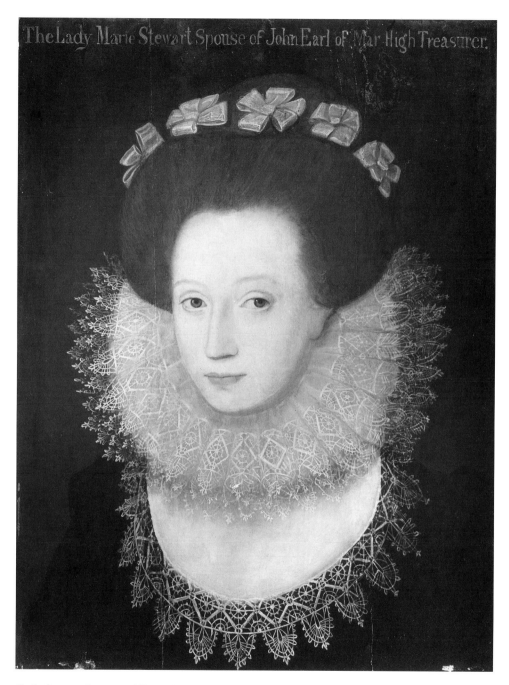

The Lady Marie Stewart Spouse of John Earl of Mar High Treasurer.

Marie Stewart, Countess of Mar, artist unknown, Scotland, seventeenth century. Oil on panel, 22¹/₂ × 17¹/₄ in. Courtesy of the Scottish National Portrait Gallery.

These commissioned portraits reflect the social status of two important women. Art and social status is a theme that can be explored across cultures in art forms as diverse as architecture, body decoration and jewelry, clothing, headdresses and hats, and memorial sculpture.

First, art *reflects or echoes*, in some way, the natural world of which it is a part. Art is *therapeutic*, because "it integrates . . . powerful contradictory and disturbing feelings, . . . allows for escape from tedium or permits temporary participation in a more desirable alternative world. . . . [Art] provides consoling illusions; promotes catharsis of disturbing emotions" (p. 37). Art can also allow *direct unselfconscious experience*. It "can temporarily restore the significance, value and integrity of sensuality and the emotional power of things, in contrast to the usual indifference of our habitual and obstructed routine of practical living" (p. 37). Art has been called "essential" because it exercises and *trains our perception of reality*. In many cultures, art may have "the unique faculty of preparing us for the onslaughts of life" (Jenkins, 1958, p. 295) by turning our attention to things that should concern us, as members of that culture; art recommends particular subject matter to our attention. Art helps to *give order* to the world. Although it contributes to order, Dissanayake also calls attention to the *dishabituation* function of art, that is, the fact that we may respond to art in unusual, nonhabitual ways. Art provides a sense of *meaning or significance or intensity* to human life that cannot be gained in any other way. Finally, art is a means through which we can reach out to others for mutuality; it is a means of *communion as well as communication*.

Lankford (1992) posits that art is valued for a number of different reasons, including the *pleasurable experiences* it provides, its *economic worth*, its *emotional impact*, its usefulness in *social criticism*, and its potential *political clout*. It is valued also for its sometimes *sentimental associations*; for its abilities to *beautify, surprise, inspire, stimulate the imagination, inform, tell stories, and record history*; for the *insight* it provides into the human condition; for its *technical accomplishments*; for its *characterization of particular cultural spirits*; and for the *status* it might afford its owner.

McFee (1986) proposes that art has six primary functions that operate to varying degrees, individually and in combination, subjectively and objectively, to affect the experiences of people in all cultures. Art *objectifies,* in that it is used to make subjective values, emotions, ideas, beliefs, and superstitions more sensuously tangible, so that they can be seen and felt. Art *enhances* and is used to enrich celebration and ritual in human events. Art also *differentiates and organizes*; it confirms ranks and roles, telling people who others are. As *communication*, art is used to record, transmit, and generate meanings, qualities, and ideas. Finally, art has a role in cultural *continuity and change*. It helps to stabilize cultures by perpetuating culture members' convictions of reality and the identities and accomplishments of individuals and groups. By identifying problems, satirizing particular conditions, and portraying alternative views, art can also destabilize cultures.

Conclusion: Broad Themes for Studying Art in a Culturally Diverse Society

Using the viewpoints summarized in this chapter, educators can develop possible cross-cultural

themes for art education curricula in a multicultural society. For example, some lessons could be devoted to art from many cultures that objectifies and perpetuates cultural values and functions to promote continuity and stability in such aspects as religion and politics. The study of art that urges change or encourages social reconstruction might include students' initiation of their own related studio projects. Students could collect art images used to enhance and enrich different cross-cultural environments. The study of different holidays and festivals is one way to show students that, across cultures, many types of art are used to celebrate and enrich major cultural events. Other lessons might concentrate on art used to record and to tell stories in several cultures. Studio projects can encourage students to tell their own important stories. Still other lessons can focus on the technical skills and accomplishments of artists from a variety of cultures. Students could be asked to compare and contrast cross-cultural examples of art through which the makers have become

> ascribers of meaning (e.g., carvers of First Nations poles in the Pacific Northwest, decorators of Ukrainian Easter eggs, makers of traditional patchwork quilts);

> ascribers of status (e.g., clothing designers, jewelers, tattoo artists, oil painters);

> catalysts of social change (e.g., graffiti artists, Chilean *arpilleristas,* gallery-based performance artists);

enhancers and decorators (e.g., makers of printed and woven textiles and ceramic tiles);

interpreters (e.g., Chinese and European landscape painters);

magicians (e.g., sand painters, holographers, mask makers);

mythmakers (e.g., commemorative artists, portraitists);

propagandists (e.g., political poster artists);

recorders of history (e.g., sculptors of public monuments, Australian Aboriginal bark painters, photographers);

sociotherapists (e.g., makers of images in a variety of media that allow us to dream and escape);

storytellers (e.g., quilt makers, picture book illustrators, those who commissioned and created Trajan's column); and

teachers (e.g., stained-glass window makers, mask makers, sand painters).

In their own art making, students can embrace some of the above roles. In contrast to some topics commonly used in art education, these theme organizers, which I will discuss in more depth in

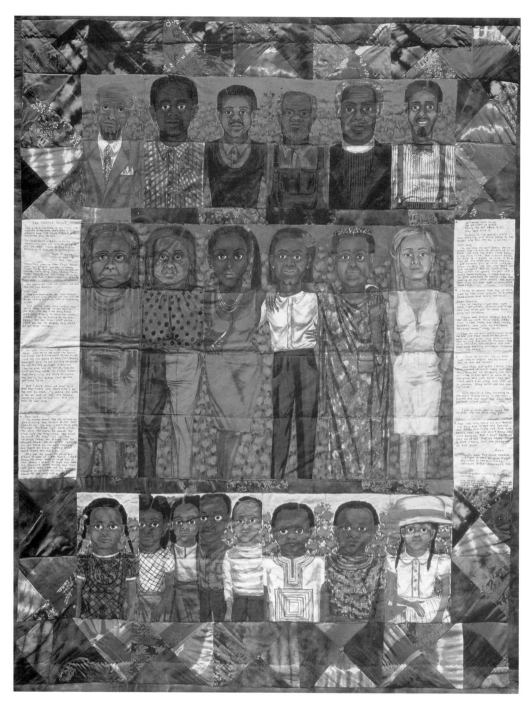

The Purple Quilt, Faith Ringgold, 1986. Acrylic on canvas, printed and pieced fabric, 91 × 72 in. Private collection, courtesy of Faith Ringgold, Inc.

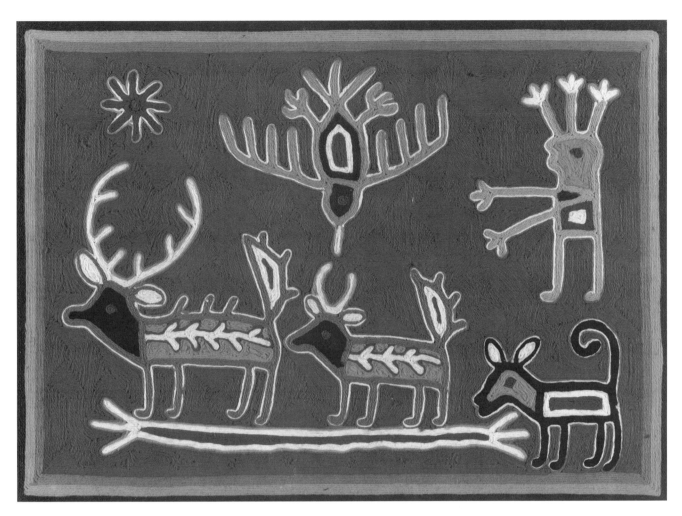

Hunting the Deer for the Sacrifice, Cersencio Perez Robles (Huichol), twentieth century. Yarn on plywood, beeswax, 15 × 21 in. Courtesy of the Fine Arts Museums of San Francisco, gift of Peter F. Young, 76.26.19.

The story quilt, recording aspects of African American experience, has been the focus of much of Faith Ringgold's work. In many cultures, such as that of the Huichol Indians, art has been used to tell stories and to record history.

the following chapters, are far from trite. They encourage us to see the *multi*cultural common functions of art. They focus on art, and they all require cross-cultural study using lenses from all the art disciplines (art production, aesthetics, art criticism, and art history).

If the focus is on the *why* of art, art teachers in multicultural societies need not worry that they do not know enough about art in a plethora of cultures. Rather than viewing teachers as transmitters of huge bodies of knowledge, we should see them as leaders and facilitators who are able to focus on the process and assist students in their investigation and understanding of commonalities in the functions and roles of art across cultures. A teacher is a leader who initiates action, maintains the teaching-learning process by setting individual and group guidelines, and evaluates students' experiences and products. When the focus is on the *why* of art, teaching is viewed as

facilitating, and learning is understood to be active, the above themes offer a wide scope for learning about and making art. Such a perspective requires a questioning, problem-solving, and inquiry-based approach to instruction.

In this chapter, I have argued that in a culturally relative approach to teaching art, the "content" area that must be considered by teacher-facilitators has most to do with three issues: why we make art, how we use art, and the functions art serves. With some knowledge of the functions and roles of art across cultures and a willingness to learn about art *with* students, multicultural art education is not as daunting as it may first appear. Teachers do not need to know everything about all cultures in order to teach the *why* of art. Art educators can embrace and implement a multicultural art curriculum based on the universal functions of art for human beings. They can focus on why cultures need art.

Pluralism and the Content of the Art Curriculum

Although in recent years many art educators have added multicultural units and examples to their existing lesson plans, most have generally been reluctant to rethink the entire art curriculum. In this chapter, I address the potential of each of the art disciplines (aesthetics, art criticism, art history, and art production) to contribute to mature and meaningful multicultural conceptions of art education. I begin by profiling some of the goals and objectives of those few existing art education programs that both acknowledge cultural diversity and focus on the why of art.

EXISTING CURRICULA

Although their efforts still need to be translated into actual curricula, schools and museums are increasingly embracing program goals that require students in art, as well as in other subjects, to value cultural identity and diversity and to discover those shared ways in which art and other institutions contribute to cultural life. Art educators are increasingly expected to be able to provide learning opportunities that will further these and similar goals. It is not satisfactory simply to add some lessons that reflect the art of different ethnic and social groups to an already crowded curriculum. Art education needs more than tokenism; as Garcia (1982) has noted, "Adding a few . . . lessons in ethnic group . . . persons or cultural contributions—perpetuates the notion that ethnics are not an integral part of society" (pp. 180–181).

CROSS-CURRICULA PROGRAM GOALS

In British Columbia's schools, students and teachers are expected

to act with awareness of the needs of a global community;

to be sensitive to issues regarding special needs, gender, race, class, and religion;

to be free of attitudes of discrimination toward persons with different racial and cultural backgrounds;

to be able to respond to racial and cultural diversity in a positive and socially responsible manner; and

to participate responsibly in a democratic society.

Adapted from British Columbia Ministry of Education (1993).

There is a long road ahead. A study published in 1990 by the National Arts Education Research Center at New York University revealed that, although the rhetoric was in place, few states had published curriculum guides for teachers with suggestions concerning how the arts might be employed in multicultural education. However, a few curriculum projects have been developed that express and reflect premises and attitudes similar to those elaborated in this monograph.[7] For example, at a local level, Barbara Fehrs-Rampolla (1989) has developed a high school art education curriculum called Accepting Diversity for a small New Jersey school district. Some of the primary objectives of this curriculum align very well with the viewpoints I have advocated in this monograph. For example, students will understand the nature of art and its functions in diverse cultures and thus learn to appreciate the variety of cultural, psychological, and historical factors that affect the forms and styles of art; students will learn that knowledge of artistic intention and cultural context are important, and that art is a symbolic language, which, although culture-bound, can often be revealed and understood through knowledge.

Other teachers working with the Getty Education Institute for the Arts in that organization's regional professional development consortia have been able to develop some outstanding individual art education units, with titles such as "Many Ways of Seeing," "Art Exploration: A Global Approach," "The Artistic Heritage of Clay: Survival and Revival of Traditions," and "Celebration!" (Alexander and Day, 1991).

Prairie Visions, the Nebraska consortium for discipline-based art education, a Getty Education Institute for the Arts regional institute, has been responsible for developing and implementing discipline-based art curricula in Nebraska. In that relatively homogeneous state, issues of diversity and cultural difference have been, and are, especially important in both staff and curriculum development. From the extensive list of objectives developed by Prairie Visions, it becomes clear that multiculturalism is not an add-on but rather an integral part of each art discipline, each unit, and each lesson. Locally developed curriculum materials, conferences, and staff development activities attempt to support these objectives (Detlefsen, 1991).

Commercially produced instructional materials illustrating the arts of many cultures are now increasingly available. These can be used to enhance and enrich the curriculum. Similarly, museums with active education departments produce useful material. With support from the Getty Education Institute for the Arts and the Office of Educational Research and Improvement, U.S. Department of Education, ERIC:ART has annotated these materials as *Resources for Teaching Art from a Multicultural Point of View* (Zimmerman and Clark, 1992). As new resources become available, this listing will be updated. It is important, however, that we do not use these materials simply to enrich existing programs with occasional multicultural add-ons. Rather, they should challenge us to undertake a major restructuring of the art curriculum.

Since 1979, the National Council for Accredi-

Acknowledging Diversity

Prairie Visions objectives include the following:

- to transform the school so that all people from diverse cultural, social class, racial, and ethnic groups will experience equal opportunities to learn

- to help all people develop more positive attitudes toward cultural, racial, ethnic, and religious groups

- to provide in-service training programs for teachers on how to make education multicultural, art instructional materials bias-free, and art curricula revisions comprehensive by including diverse ethnic and cultural content

- to encourage an awareness of ethnic cultural observances within a populated area

- to provide an ongoing curriculum that values and affirms differences and avoids stereotyping

- to foster an appreciation of cultural development and cultural heritage

- to develop awareness of how culture is maintained within social groups

- to develop appreciation of how the visual arts affect a social or cultural unit

- to develop appreciation for the varying views of what art is from one society to another

- to develop recognition that art can give identity to people through symbols

- to identify the many roles of art and artists in a variety of settings and backgrounds

- to develop recognition of the economic, political, and social roles of artists

- to develop recognition of the ways artists preserve the cultural heritage of a society

tation of Teacher Education has required teacher education programs to "become more responsive to the human condition, individual cultural integrity, and cultural pluralism in society" (National Council for Accreditation of Teacher Education, 1979, p. 13).

More than 20 years ago, the council suggested the following:

Multicultural education could include but not be limited to experiences which: (1) promote analytical and evaluative abilities to confront

issues such as participatory democracy, racism and sexism, and the parity of power; (2) develop skills for values clarification including the study of the manifest and latent transmission of values; (3) examine the dynamics of diverse cultures and the implications for developing professional education strategies; and (4) develop appropriate professional education strategies.
(p. 13)

However, by 1990 the National Arts Education Research Center found that institutions generally had not addressed the need to restructure programs leading to the preparation and certification of art teachers to prepare them to deal with cultural issues in general and multicultural concerns in particular.

LEVELS OF COMMITMENT TO MULTICULTURAL ART EDUCATION

As Banks (1989) has emphatically stated, art education curricula must move beyond the simple "contributions approach," in which heroes, heroines, and holidays are simply added to the existing curriculum on special days as additional topics or as themes for rather trivial art-making activities. What Banks has called the "additive approach" goes a step further, but still not far enough. Adding Japanese woodblock printing to a unit on James McNeil Whistler could be considered additive, for instance. As Banks argues, this approach reinforces the idea that ethnic histories and cultures are not integral parts of U.S. mainstream culture; that is, it encourages students to

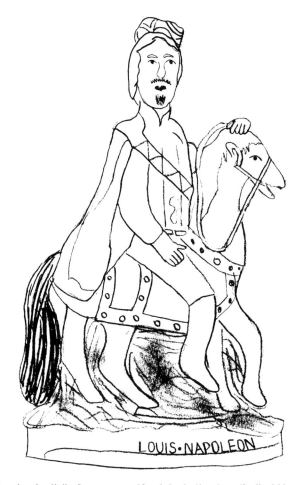

Drawing by Holly Bennett, age 12, of *Louis Napoleon* (Staffordshire, England), ca. 1854. Glazed earthenware. Drawn from a reproduction of a work in the Girard Foundation Collection in the Museum of International Folk Art, a unit of the Museum of New Mexico.

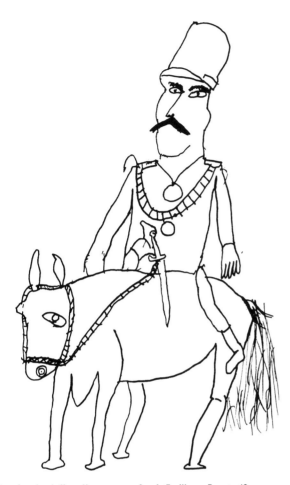

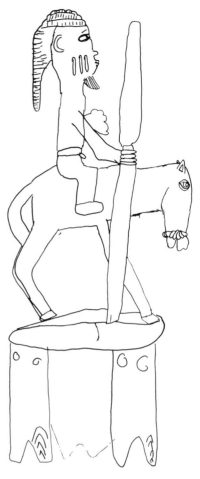

Drawing by Jeffrey Hutson, age 9, of *Emiliano Zapata* (Oaxaca, Mexico), David Villafanez, ca. 1970. Painted wood. Drawn from a reproduction of a work in the Girard Foundation Collection in the Museum of International Folk Art, a unit of the Museum of New Mexico.

Drawing by Colleen Parkes, age 10, of *Horseman* (Yoruba people, Nigeria), ca. 1960. Painted wood. Drawn from a reproduction of a work in the Girard Foundation Collection in the Museum of International Folk Art, a unit of the Museum of New Mexico.

The act of drawing these images from Europe, Central America, and Africa helped students in Stan Thomson's classes at Kanaka Creek Elementary School, in British Columbia's Maple Ridge-Pitt Meadows School District, consider the theme of male power and leadership in the sculpture of diverse cultural groups. They gathered related images from other cultures and discussed aesthetic and contextual issues. At the decision-making and social action level, students could question the appropriateness of, and suggest alternatives to, the image of the mounted male warrior as a symbol of cultural achievement and power.

view ethnic groups from Anglocentric or Eurocentric perspectives. In a multicultural society, the additive approach does nothing to help students understand how the dominant culture and other cultures are interconnected and interrelated.

Although the contributions and additive approaches represent possible beginnings for helping students to understand art from other cultures and other cultures in general, they do not go far enough. Art education must move toward what Banks calls the "transformation approach," which I would relabel the *cross-cultural understanding approach*. An art curriculum based on this approach requires that concepts, issues, problems, and themes be viewed from the multiple perspectives of diverse cultural, ethnic, and racial groups. This is similar to Hamblen's (1986) "universal-relative" approach, and it is also compatible with many of the functions and roles of art suggested in Chapter 3. A curriculum might include, for example, attention to art as a life-sustaining activity:

> *Life sustaining needs, activities and phases are areas of concern that find expression in themes found in art throughout the world. Themes of procreation, security, fear and domination find expression in fertility figures, ceremonial items used to assuage the gods, the decorated battle gear of soldiers and the portable wealth of jewelry used as body adornment. Art functions to mark the importance and meanings of individuals, activities and environments. (Hamblen, 1986, p. 74)*

Brent Wilson (in press) reports on an appropriately cross-cultural unit developed by Susan Shafer, who worked with other teachers and staff at the Art Center in Mansfield, Ohio. In this unit, students explored some relationships between East and West by comparing and contrasting Japanese landscape painting with nineteenth-century paintings of the American wilderness, and by analyzing differences in how an American artist, Winslow Homer, and a Japanese artist, Hokusai, depicted the sea.

A final approach that Banks (1989) identifies is the "decision-making and social action" approach, which moves beyond understanding art in cross-cultural contexts and has implications for the study and creation of art as a form of social action. If students are to address actively such issues as racism, sexism, and some of the themes suggested in Chapter 3, this is the appropriate approach. Among the few published curriculum projects that encourage students to make art for social change are the "Art and Development Education" materials produced by Oxfam (1990) in the United Kingdom. These materials are the result of a three-year project in London's inner-city intermediate and secondary schools. The project focused on addressing racism and apartheid through art-based approaches. Oxfam also produced a video titled *Art as Social Action* (see Oxfam, 1990). In a similar vein, the London-based group Art and Society, working with Amnesty International (1991), produced an art education teaching pack titled *Free Expression*.

Many researchers and educators believe that a

multicultural approach to education in general must eventually lead to social action. Sleeter and Grant (1987), who, as discussed in Chapter 1, have described five different multicultural approaches in U.S. education, share this view. Zimmerman (1990b) and Stuhr (1991) first introduced these five approaches to art educators:

- The first approach is simply to add lessons and units with some ethnic content.

- The second approach focuses on cross-cultural celebrations, such as holiday art, and is intended to foster classroom goodwill and harmony.

- The third approach emphasizes the art of particular groups—for example, African American art or women's art—for reasons of equity and social justice.

- The fourth approach tries to reflect sociocultural diversity in a curriculum designed to be both multiethnic and multicultural.

- The fifth approach, decision making and social action, requires teachers and students to move beyond acknowledgment of diversity and to question and challenge the dominant culture's art world canons and structures. In this approach, art education becomes an agent for social reconstruction, and students

get involved in studying and using art to expose and challenge all types of oppression. Although this last approach may not be multicultural per se, students will probably be dealing with issues that cross many cultural boundaries.

My position is that to understand art from other cultures, and to understand other cultures in general, art educators should *at least* be using Sleeter and Grant's fourth approach, reflecting sociocultural diversity in the curriculum, which is similar to what I have called a cross-cultural understanding approach. The curriculum needs to be reformulated so that it emphasizes the unity within our diversity, showing that all humans make and use art for fairly similar reasons. But, unfortunately, there are issues, such as racism and sexism, that absolutely require us to implement approaches in which art making and learning become ways to participate in social reconstruction.

Observations of classroom practice suggest that, except in a few instances, art educators have made commitments only to the lower-level approaches identified by Banks (1989) and Sleeter and Grant (1987). How do we move to the higher levels to reflect sociocultural diversity in the curriculum and encourage decision making and social action while keeping instruction grounded in exploring the common functions of art across cultures? In the sections that follow, I offer suggestions for the steps that can be taken within each of the four art

disciplines. Although for the sake of clarity I will discuss each of the art disciplines in turn, I realize that the disciplines may rarely be taught as separate components. The disciplines provide sometimes overlapping lenses for understanding and appreciating the art of many cultures.

ART PRODUCTION

Multicultural art production has too often taken the form of students' making Ukrainian Easter eggs one week, doing some Japanese paper folding another, and, then, perhaps, making a totem pole out of the insides of toilet paper rolls to complete the "unit." Multicultural art education has typically been conceived as a few activities, a unit or two, resulting in take-home products, but not as an "attitude." It should be obvious that such tokenism "not only trivializes the aesthetic production of all sociocultural groups, but, what is worse, it avoids confronting the real challenge of critically apprehending the meaning of the object, artist, and process in the sociocultural context" (Stuhr, Petrovich-Mwaniki, and Wasson, 1992, p. 21)

Other approaches to multicultural art production have sometimes been multicultural learning experiences posing as art activities. For example, although it may be laudable to teach students about a variety of skin colors by having them mix different flesh tones with tempera paint, this is not necessarily an art activity.

Art educators should be careful not to endorse curricula and curriculum materials that suggest a smorgasbord of different studio activities as a way of learning about and experiencing the arts and crafts of other cultures. I recently reviewed a "multicultural" art curriculum that, on the surface, may appear less trivial than some, because it organizes activities around three levels of skill and concept and supposedly integrates art with the social sciences (Ryan, 1989). The curriculum lists 23 art production skills, such as dyeing, knotting, impressing, and weaving. Certainly these skills are multicultural, and their inclusion questions the hierarchy of art media and forms endorsed by the Western canon. However, the concepts to be taught are mainly the formalist elements and principles of design, which are listed as balance, contrast, dominance, dynamics, harmony, repetition, rhythm, simplification, transition, unity, and variety.

Although this curriculum fosters some sense of learning about art in society, this is largely incidental; for the most part, it concentrates on the making of rather spurious copies of "ethnic" art. The author even states, "The materials for these projects can often be had by collecting throw-aways or household materials" (p. 1). The stated learning outcomes of this curriculum may be laudable, but in the process of translating them into classroom "activities," the author trivializes the art forms and techniques being studied. I am not opposed to teachers' using found materials in art classes, but they should keep in mind that if students are told they can copy some peoples' art forms cheaply and effortlessly, this can leave the impression that some art is not worth very much. In dealing with problems of "making" in

response to Australian Aboriginal art and design, Fraser and Stevenson (1990) refer to this approach as " plagiarism." They suggest positive ways of using Aboriginal art, craft, design, and culture for inspiration in the studio (e.g., use of X-ray images, magnification, dot patterns) rather than simply copying and trivializing Aboriginal images.

The Victoria and Albert Museum's Nehru Gallery National Textile Project (illustrated on page 27) is a good example of an innovative and unique project that encouraged the public to use artworks for inspiration and study and to realize that art is not always created by one solitary artist. Groups of South Asian women and schoolchildren from across England were invited, and funded, to design and make embroidered and decorated tent hangings following visits to the gallery. Often, within these groups, three generations of South Asian immigrant women from the same families worked together in attempting to reclaim parts of their own histories. Non-Asian school groups used the project as an introduction to South Asian culture. The museum educator in charge of the project reports that for most of the participating women it was their first visit to a museum and their first realization that the museum collections could be "theirs" (Akbar, 1993). The project was seen to reawaken traditional skills and to release latent talents. The participants' images drew from both English and Mughal cultures, and the experience introduced immigrant women to new techniques and unlocked rich and creative design abilities. Both the women and the schoolchildren learned that art can be produced, with a variety of materials, by cohesive and cooperative groups. In this project, multicultural art learning went beyond techniques, tools, and materials, and participants saw art as a powerful force reflecting and shaping people's visions of the world.

Art educators can extend what was learned by students and community members in the Nehru Gallery National Textile Project to design even more multicultural projects. Participants could study embroidered textiles from medieval Europe, China, and Japan that convey a similar theme of nature imbued with spiritual and symbolic meaning, not just to understand the techniques, tools, and materials used, but as a prelude to studio projects associated with landscape, nature, and symbolic meaning.

When considering approaches similar to Banks's (1989) decision-making and social action approach and Sleeter and Grant's (1987) social reconstruction approach, English art educator Rachel Mason (1988) notes she can see

> *no good reason why art and design teachers should not encourage Black pupils to express strong views about the structural inequalities of contemporary . . . life in and through the media of the visual arts, although I would hesitate to promote this as a means for their survival. . . . But I found few records of any formal attempts by teachers to set up art projects in which pupils attempted to communicate their experience of racial injustice or to celebrate Black resistance. (pp. 89–90)[8]*

Schools might get involved with local organizations such as the Social and Public Art Resource

Center (SPARC) in Los Angeles, which was founded in 1976 to create, present, and preserve public art. This organization grew out of community mural projects, most notably the *Great Wall of Los Angeles* (see page 57). Community murals are still an important part of the SPARC's mandate; in addition, a gallery presents shows such as *In the Shadow*, an exhibition of youth artists' work on ethnicity and age, and *Confrontation*, a show in which artists of different backgrounds confronted issues of race and racism (see Gordon, 1992).

Kids Speak Out was one of a number of socially motivated projects developed by Artists/Teachers Concerned, a group of artists and teachers working in areas of great cultural diversity in New York City. Within this multicultural arena, student work was seen and student voices were heard beyond the classroom, as their work was projected for several evenings on an outside wall at a New York City intersection. The black-and-white images culled from 29 schools throughout the New York metropolitan area represented the work of more than 500 students. In their artwork, the students addressed a wide range of social and cross-cultural issues, including drug abuse, environmental pollution, teenage suicide, crime, endangered species, and education. A similar show, *Stop, Look, and Learn,* was exhibited in storefront display windows along 8th Avenue. An undated Artists/Teachers Concerned brochure states:

> *For many of our students real choices and opportunities are few or nonexistent. In this context, the need for a meaningful art educa-*

tion curriculum . . . is clear. Through socially motivated art education programs and exhibits we give our students a chance to actively voice their opinions and be recognized for caring about themselves and their future.

As educators, if we are going to honestly tell our students that they have the power to criticize and change their situation and society, then we have to believe that our educational system will reinforce those objectives and facilitate the atmosphere in which such changes can occur.

Approaches such as those described above can be implemented in suburbs as well as in cities. In 1991, a local newspaper's claim that at least 40 percent of Canadians have racist attitudes, coupled with observed racist behavior within area schools, prompted some Burnaby, British Columbia, art, theater arts, and English teachers working with ninth and tenth graders to develop a unit called "Art against Racism" (Scarr and Paul, 1992). A local arts organization, Arts in Action, had recently sponsored an exhibition titled *Fear of Others: Art against Racism* and had developed a slide set, video, and guide. Other videos (*Skin; Yourself, Myself*) as well as a variety of books and posters were used to introduce students to multicultural viewpoints concerning such issues as the power of the arts to express both hope and oppression. As in the materials developed by Amnesty International (1991) and Oxfam (1990), the visual arts part of the unit required students to respond to a variety of visual materials on issues of racism, to develop their own statements

about racism, to develop original images suitable for the linocut printmaking process, to produce together an edition of signed prints, to develop together a written or oral statement to complement that folio, and to respond to their own work and the work of others, attending to both the intrinsic formalist qualities and the extrinsic contextual qualities of the prints. The language arts class produced poems and short stories, and the theater arts class wrote and staged a play that investigated racist behaviors and attitudes. All the students created a large mural, 6 by 30 feet, as a joint celebration of the awareness they had developed. With additional funding from the school district, the students went on tour to present their work to students at other schools, and some of the work was used for the cover and illustrations in a special issue on multiculturalism published by the *British Columbia Art Teachers Association Journal for Art Teachers.*

Vincent Lanier (1969, 1980) has called for the use of art education, particularly through "newer media," to transform society. Student photographers and video artists should have the opportunity to learn about and embrace the functions and roles of art outlined by Gerbrands (1957) and others (as discussed in Chapter 3).

In considering students as makers of art, art educators may want to address several questions. For example, do student artists, like other artists across cultures, function as cultural transmitters and sustainers; as catalysts for social change; and as magicians, teachers, and mythmakers? Does their work support and/or challenge particular cultural values?

Does their work give us new insight or make us look with renewed awe and wonder? When we view student artists' work, what are we learning, beyond a respect for technique and the use of appropriate elements and principles of design?

In an essay in which she discusses a pedagogy for multiculturalizing art education, Heard (1989) draws upon the work of Bowles and Gintis (1976) and claims that "the notion of multicultural education is implicit in an education that takes as primary the integrity of the individual"(p. 12). In such a setting, "the individual is seen as a carrier of culture and . . . educators recognize that culture resides in the individual" (p. 12). I believe that multicultural education becomes a very real possibility in studio art classes when teachers encourage the development and expression of authentic personal images in a great variety of media. Marilyn Zurmuehlen (1990) has eloquently underscored this point:

> *Art classes are sites where energy can be realized in action, students can be originators: intending, acting, realizing, . . . re-intending, combining critical reflection and action. . . . They can be transformers as well, symbolically transfiguring the idiosyncratic meanings of their life experiences into the representational symbols of art . . . making art as vital to curriculum as it is to culture: when we recognize ourselves in both of these spheres as originators, transformers and reclaimers, we participate in the sense of . . . once . . . now . . . then . . . that shapes our individual and collective life stories. (pp. 64–65)*

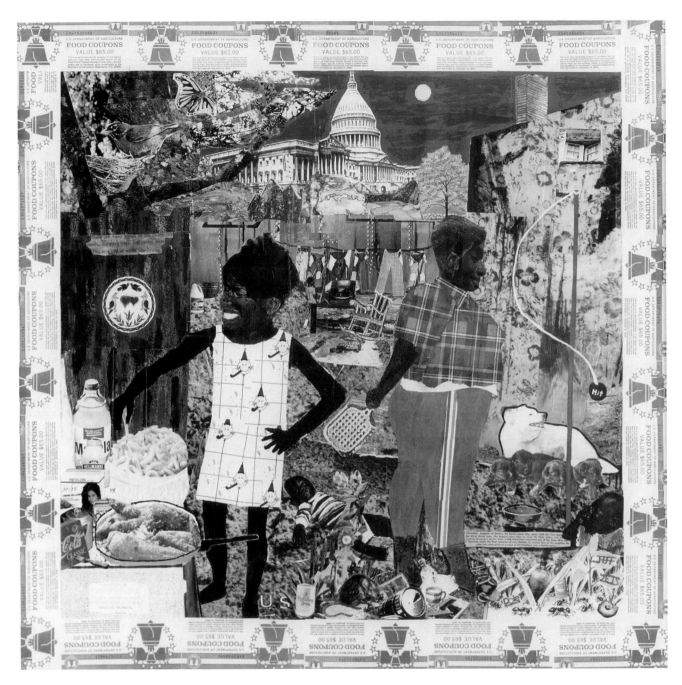

Martinique, Jeff Zets, 1993. Mixed media, 31 × 31½ in. Courtesy of Gasperi Gallery, New Orleans.

Collage and photomontage as social commentary.

Most educators would agree that we must help young people have a positive view of the future and to believe that we/they can do better and live better. There is certainly a role here for studio art programs. Students might investigate art as advocacy and develop this aspect in their own studio work. Also, "placing white, middle-class culture within the galaxy of our multiple ethnic, social and cultural groups rather than at the center" (Garcia, 1982, p. 177) will help to purge the curriculum of the trivial and impotent artwork we see on school bulletin boards—art that epitomizes what Efland (1976) has labeled the "school art style." Art educators should not place any art near or outside the margins of society. When all categories of art can be equally valid, and when definitions of quality come from within each category, no one is the other or the outsider and no art medium is superior to any other; the distinction between art and craft becomes blurred and nonhierarchical.

AESTHETICS

Aesthetic inquiry is sometimes defined as "talk about the talk about art." As Hamblen and Galanes (1991) put it: "Aesthetic inquiry involves an examination of what is said about art. It is not an examination *of* art objects per se, but *about* meanings, values, descriptions . . . given to art. . . . [It] is an examination of various forms of talk about art" (p. 16). This is an important definition. All cultures engage in talk about art (broadly defined). Do individuals listen to

that talk? The talk about art that students examine should be as diverse as the art forms they study. In addition to experts, what do ordinary people, in a variety of cultural contexts, say about art?

In a paper that introduced discipline-based art education to British audiences, Eisner (1988) states that "understanding the *variety* of criteria that can be applied to works of art and reflecting about the meanings of that intellectually delicious and elusive concept 'art' is what much of aesthetics is about" (p. 189; emphasis added). Although I have suggested in earlier work that within DBAE aesthetics can sometimes, and too frequently, seem to equal Eurocentric philosophical aesthetics, and art history be seen as the study of Western monuments (Chalmers, 1987a), this, of course, need not be the case. We need to acknowledge that expert opinion does not always reside with Western aestheticians and other experts. Art programs should include many kinds of experts, not the least of whom should be members of the cultures that produced the art that is being discussed. Community interaction is also important. Art educators in museums, as well as in schools, should be careful to avoid always giving prominence to the dominant (majority) culture's ways of looking at art.

Art educators should be suspicious of programs that assess and judge all art only according to Western aesthetic tenets. Hart (1991), who defines Western aesthetics as being primarily concerned with individuality, originality, permanence, and form, has shown that these are not universally applicable criteria for defining artistic excellence in all cultures.

Some African art, for example, can be best understood in terms of rites of passage, healing, power, control, and commerce (Chanda, 1993).

Although we can appreciate the art of cultures other than our own, we may not necessarily understand it. To understand rather than just appreciate art, it is essential to comprehend the principles of "good" art as they are understood by the social group that holds them. The same standards cannot be applied across all cultures because, as anthropologists and others have shown, "members of different cultures simply do not react in the same ways to the same stimuli" (Kaepler, 1976, p. 21). However, this remains a controversial claim. The possibility that there may exist universal aesthetic standards has been suggested by Gotshalk (1962), Rosenberg (1959), Child and Siroto (1965), Ford, Prothro, and Child (1966), Iwao and Child (1966), Iwao, Child, and Garcia (1969), and Iwawaki, Eysenck, and Gotz (1969). Opposed to this view are researchers such as Segall, Campbell, and Herskovits (1966), who present evidence for culturally mediated differences in perception that suggest the existence of different cultural bases for aesthetic evaluations.

In the end, we might opt for something close to the view articulated by Jacques Maquet (1979, 1986). In his pioneering *Introduction to Aesthetic Anthropology*, Maquet (1979) postulates a universal aesthetic sensibility. However, he defines aesthetic sensibility as "the capacity to be aesthetically aware but not necessarily to respond the same way to the same stimuli" (p. 24). Maquet presents three arguments in favor of the universality of aesthetic sensibility. First, because craftspeople have aesthetic concerns, they are not content with designing forms solely so that they may be efficiently used, and, because consumers have aesthetic appreciation, they prefer owning implements designed for more than simply efficient use. Second, Maquet argues that acting, thinking, feeling emotions, and contemplating are functions of the human organism that are universally shared. Therefore, just as men and women are thinking animals, they may be said to be aesthetic animals. His third argument centers on the simple fact that in many cultures concern for and appreciation of aesthetic values is explicitly expressed. Although the near universality of aesthetic sensibility contributes to the sense of unity so important in a multicultural society, it does not mean that all humans necessarily respond to the same things in the same ways. The unity is found in the fact that all humans, in all cultures, have the capacity to be aesthetically aware.

Like the other art disciplines, aesthetics continues to change as we recognize and seek to understand the art forms of a postmodern multicultural world. Institutional theory, critical theory, feminist theory, gay and lesbian studies, and Marxist aesthetics all call for increasing acknowledgment of the many social forces that motivate, direct, influence, and define art and that, within various cultures, may be used to evaluate artists and their work. Although some languages have no words equivalent to the English word *art*, all cultures are involved in "mak-

ing special" (Dissanayake, 1988, 1992) and all "have concerns about how things look and traditions associated with the use, meaning, and expressiveness of forms and colors" (Lankford, 1992, p. 15). Some form of aesthetic concept or theory has been, or appears to be, part of every culture (Anderson, 1990). Multicultural art education needs to reflect this reality.

As an indication that aesthetics, as a discipline, is becoming more inclusive, consider the lack of ethnocentrism and the appropriately broad perspective in the following goals and objectives taken from a list of 18 that appear in a recent aesthetics handbook for teachers (Lankford, 1992):

- Students will learn about traditional and alternative art theories [and, presumably, note that what is considered traditional or alternative will depend on who is being read or listened to].

- Students will recognize that concepts of art vary among cultures and can change over time.

- Students will recognize that works of art can be valued in many different ways.

- Students will attempt to discover the values their families, friends, and communities hold toward art.

- Students will study individual and social values as they are manifested in works of art.

- Students will learn about institutions and social networks that sustain and influence the arts.

- Students will be introduced to different forms of arts patronage that have occurred throughout history and across cultures.

- Students will generate [lists of] characteristics that identify a person as an artist. (pp. 69–70)

Art educators have also become increasingly aware that folk art and popular art have a place in art education; they should be careful not to neglect aesthetic discussion in these areas. For example, a number of researchers have shown that clothing is a prime means of aesthetic experience for members of some cultures. Holloman (1989) cites evidence that members of some groups in the United States spend greater portions of their incomes on clothing than do members of other groups. Tricarico (1991) has investigated "style," particularly how clothing, jewelry, hair, music, talk, and other actions are used within some urban youth cultures as "meaningful symbolism," "dramaturgical statement," "managed image," "loaded surface," and "expressive artifice." Visual elements such as dress and movement are important aspects of musical performances in many cultural groups. There are many wonderful possibilities for

cross-cultural aesthetic discussion. Such discussions already take place in the school halls, and they should also take place in art classrooms. Aesthetic inquiry is often associated with "doing philosophy." Philosophy becomes accessible when familiar objects and familiar talk become the focus of the questions. Art educators might find it useful to start with objects and talk from local popular cultures. In this local context, they can begin to ask the questions, What is art? and What is art for?

Art Criticism

Just as all cultures talk about art (or cultural artifacts), all cultures engage in forms of art criticism. As I have noted throughout this monograph, art educators should demonstrate that we all need and use art for rather similar reasons. In this sense (and, if we are not to be culture-bound and elitist, it is the only sense that makes any sense), Asian art is as "valid" as European art, popular art is as "valid" as high art, and so on. This does not mean that there is not good and bad Asian art, good and bad European art, good and bad popular art, but we cannot judge them all as part of the same category. Any one category of art cannot be said to be better than another. Of course, art criticism is concerned with quality, but critics need to broaden their notions of quality, particularly to include work outside European-based definitions and histories.

Art educators should make explicit the dominant culture's value system embedded and implicit in such well-used classroom rituals as Feldman's

(1970) description-analysis-interpretation-judgment model for art criticism. If they do so successfully, students will be able to process dominant-culture information from their particular cultural perspectives and "assess whether it can be personalized and utilized without destructively infringing upon their cultural world view" (Nakonechny, 1989, p. 13).

We should not always feel obliged to judge art. Art educators need to adopt an anthropological attitude toward art criticism. As Blandy and Congdon (1987b) have suggested, art criticism should "include the critical processes developed and utilized by the Iowa farm family, the Harlem native, and the Mississippi beautician" (p. xvii). The ways in which different people talk about and interpret art should not only be affirmed in the art classroom, they should also challenge educators' own perceptions of quality and help them to see that each cultural art form has its own definitions of quality and worth. The longtime quilt maker, the decorator of panel vans, the chainsaw carver, and the local potter all have the right to their interpretations, to express their own judgments, and to have their artistic creativity acknowledged and affirmed. Art educators need to learn that there can even be both "good" and "bad" paintings on black velvet.

One of the accepted approaches to multicultural education is to start with the familiar. Martin Lindauer has made numerous studies of what he calls "cheap" or "mass-produced" art (also sometimes known as factory art or kitsch). Such work is consumed by members of diverse cultural groups. Lindauer (1990) has posited that, for doing art criti-

cism, mass-produced art has an advantage over museum art because it is easier to find and more familiar. He suggests that a question such as "What do you think or like about this work of art?" may be easier to understand when asked about a mass-produced piece and may, in many sectors of society, lead to very comprehensive and interesting answers. A customer in a store or a homeowner considering the purchase of mass-produced art may offer a less awed and intimidated answer than a museum visitor facing a masterpiece, because he or she is committed to living with the art and the museum visitor is just passing through (p. 108).

Like others concerned with the social construction of meaning, Griswold (1987) argues that meaning, rather than being found exclusively and unalterably within an object, is the result of social interpretation. She shows how the same novels have been understood and interpreted quite differently by critics in three different cultures. Doesn't the same thing happen with the visual arts? Fred Wilson, a curator-artist of both Native American and African American heritages, has produced some exciting exhibitions with great potential for critical studies in art education.[9] What happens, for example, when similar art is exhibited in the clinical white space of a contemporary gallery, in a brown "ethnographic" space with much attention given to documentation and labeling, or in the aristocratic and plush environment of a nineteenth-century salon? What happens when African masks are wrapped in French or British flags and exhibited as spoils? How does changing the label on a piece from "courtesy of the British Museum" to "stolen from the Zonge tribe" affect perception of the object?

Teachers and students who want to move art criticism into the arena of social reconstruction might debate some of the issues raised by Eric Gordon (1992) in a manuscript submitted to both the *Los Angeles Times* and *Artweek*, but published by neither. (The article ultimately appeared in *S.P.A.R.C.plug*, a newsletter put out by SPARC.) Gordon is concerned that establishment art critics rarely respond to public murals. Because it serves as a reminder that all students can start with the art forms in their own neighborhoods, and because it is so pertinent to the sort of discussion that should go on in art classes, I reproduce here, with permission, part of Gordon's plea:

> *A few . . . community newspapers give . . . murals some coverage . . . [and] will report a new mural as a local color story. . . . At most . . . [major newspapers and art journals] publish an event listing when the mural is dedicated, but rarely does a photographer show up, and never does an art critic write a review. At best murals are treated as a kind of orphan-child of the art world, to be coddled with an occasional well-meaning mention. When writers do address the subject, they write sociology: murals as part of the anti-graffiti beautification program, as a means of employing underprivileged youth assistants, as colorful and sometimes meaningful additions to the dreary urban environment. They garner far more public than professional interest. . . .*

I would suggest that the reason for this critical oversight is racism. If that word is too strong, how about: discomfort traveling about the city to areas unfamiliar on the art circuit; resistance to thinking about artistic standards in non-Anglo cultures; patronizing attitudes about "street art" or "barrio art"; fear of seeming to legitimize graffiti—as if murals are only one step up from vandalism; a nagging suspicion that the mural form is an outdated vestige of the 1930s Works Progress Administration, too "civic-minded" for a generation wedded to Abstract Expressionism; rejection of political or ethnic-pride themes sometimes stated in murals. Need I go on? In the final analysis racism may not actually be such a poor word choice.

Critical inattention notwithstanding, murals are seen, over the course of their lives, by millions of people. Murals do indeed have "messages"—da Vinci's Last Supper, *Michelangelo's Sistine Chapel, or Diego Rivera's works come to mind. The impact they have on their audience is far more powerful and long-lasting than that created by almost any gallery show—though ironically, most . . . muralists also show in galleries.*

Artists who choose to paint for all the world, not just for a restricted clique of gallery-goers, merit attention. Their skills [may] have been honed in the same art schools as other artists; their values and ideas are of equal validity. For their own growth and development

they need to be evaluated by the same informed criteria applied to other artists. The truths they bring us need not be kept a neighborhood secret.

At the same time, critics need to be aware that public art serves distinct audiences and purposes. (pp. 5, 14)

Becoming aware that art serves distinct audiences and purposes across cultures is central to multicultural education. Students might examine local and national newspapers and art magazines to see if those publications are including a variety of art from diverse cultures. If not, what further action can students take? Perhaps a plea to the media such as Gordon's would be in order.

ART HISTORY

Art education and cultural diversity have been particularly well served by the recent publication of two books on the teaching of art history: *Art History and Education* (Addiss and Erickson, 1993) and *Art History: A Contextual Inquiry Course* (Fitzpatrick, 1992). Both texts present views of art history that can be implemented easily in school programs and that are compatible with a multicultural approach to teaching and learning.

One of the first things art educators need to realize is that there is no single history of art. Rather, art has many different and competing histories and herstories. The differences for the most part stem less from the correctness of the information and the thoroughness of the research than from differing

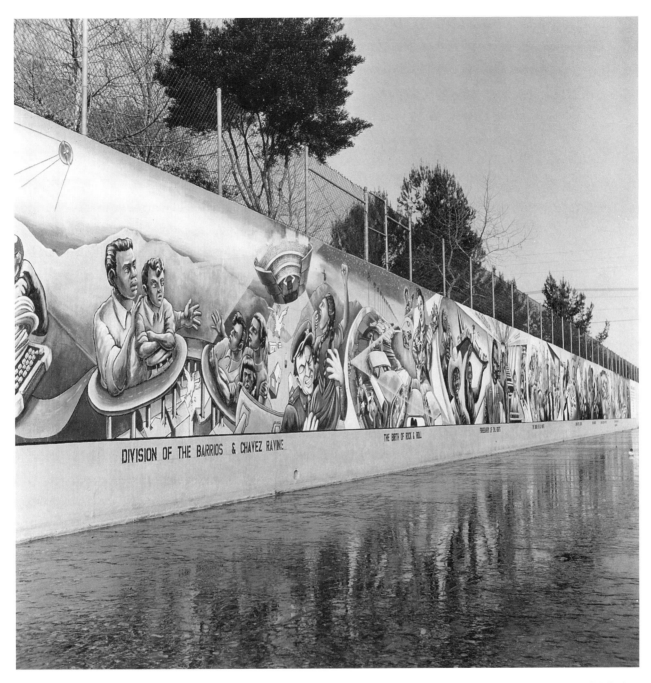

The Great Wall of Los Angeles, Judy Baca, 1974–83 acrylic paint on concrete, 13 × 2,400 ft. Courtesy of the Social and Public Art Resource Center, Venice, California.

Art for more than "a restricted clique of gallery-goers."

social agendas. Art history now embraces cultural and sociological issues that were once assumed peripheral to both art history and art education (Freedman, 1991). The study of art history must become more than a canonized chronology of Western masterpieces. In a culturally diverse society, art histories must not only embrace art produced in all parts of the world but must pay attention to a wide variety of art forms, as well as the art of women and members of other groups who are or have been politically and aesthetically oppressed.

Serious revisionism in art history began with feminism (Nochlin and Harris, 1971) and expanded to include other political issues. Semiotics, feminism, Marxism, and deconstruction have all challenged the "doing" of art history—but not yet in the schools, where

> *concepts such as the Middle Ages and the Renaissance are still used to organize most units in history, literature, and the arts. When content about African and Asian cultures is incorporated into the curriculum, it is usually viewed within the context of European concepts and paradigms. For example, Asian, African, and American histories are often studied under the topic, "The Age of Discovery," which means the time when Europeans first arrived in these continents. (Banks, 1992, p. 33)*

Similarly, art educators can perpetuate racist notions by teaching about the art of ancient Egypt while denying, or omitting, that Egypt is a country in North Africa (DePillars, 1990; Dufrene, 1994; Spruill-Fleming, 1990).

Art educators generally agree that teaching art history does not mean lecturing to students in the manner of some instructors of introductory college-level survey courses. Art history is an inquiry process, requiring description, analysis, and interpretation. It involves the historical "examination of the work of art, the artist, the artist's culture, and other societal and personal influences on the creation [and use and consumption] of art" (Fitzpatrick, 1992, p. 2). As discussed in Chapter 1, art history is rediscovering its anthropological roots in both foci and methodologies. The "new" art history is particularly appropriate for the study of art in multicultural societies, because it approaches the subject from the standpoint of cultural histories; particular objects are studied as commodities within particular socioaesthetic systems (Pointon, 1986). In the new art history, both intrinsic/formal and extrinsic/contextual methods are used. Thus, both the look of the work and the *meaning* of the work are considered.

It is important that students *do* art history, and not just read about "old art" in conventional art history texts. They need to see the methods of art history, which are increasingly being adopted from other disciplines, especially the social sciences: hypothesis testing, problem solving, hands-on detective work. Art history in schools should be *active.* Art historians describe, analyze, and interpret works of art according to their materials and modes of production, their makers, their times and places of creation, and particularly their meanings or functions (Kleinbauer, 1987). Such exploration does not always happen in a library.

Using the work of Triandis (1983), McFee (1986) implies that the art of a culture can be understood only when we seek answers to questions such as the following:

- What are the norms for artistic behavior [in that culture]; who does what, when, and how?

- What is the relationship of the artist to the rest of the group [culture]?

- What are the ways that artists express the general intentions of the group?

- How does a given artist's self-concept compare with the norms for other people in the group? What values are clearly accepted or rejected in and through the art of the group? What are the group's beliefs about art's antecedents and consequences? What is art based on?

- What effects is [art] expected to have? How much variation in artistic behavior is tolerated? How [is] the artist . . . rewarded? (p. 11)

McFee recommends also these questions about the interrelationship between art and culture:

- What are the cultural influences on the creation of a given group's art?

- How does the art reflect that culture?

- How does art enhance and transmit cultural values, qualities, attitudes, beliefs, and roles?

- What are the criteria for judging art?

- What are the emergent qualities in art and the culture?

- What is the role of the artist in the culture?

- How does an individual learn to be an artist?

- Where does a given artist fit within the cultural group? (p. 14)

These and similar questions should be asked frequently within art curricula. To answer them, students need to be exposed to the study of archival documents, diaries, newspapers, and other memorabilia in addition to the study of art objects.

To move art history into the arena of social reconstruction, for example, educators might have students consider the history of collecting. Cultural objects can reflect both their original meanings and the meanings they have for new audiences in different social contexts. What happens, for example, to non-Western and other artifacts when they have been relocated in Western museums? (See the previous discussion of Fred Wilson's work.) Older students could usefully discuss Clifford's (1988) observation that for more than a hundred years, objects collected from non-Western cultures have been classified mostly as anthropological specimens.

Only a very few objects have had the qualities defined by most Western experts as those required of works of art.[10]

Also within the arena of social reconstruction, and in an attempt to desegregate the curriculum further, teachers and some older students may focus on histories of gay and lesbian art.[11] Certainly, the art of such groups has received little if any attention in the secondary art curriculum. An exception is a study by Barrett and Rab (1990), who describe a student field trip to a controversial Robert Mapplethorpe photography exhibition. The accounts and reactions provided by the participants (the 18-year-old students, accompanying high school English teacher, and art education professor) suggest that, in addition to formal qualities, public schools *can* successfully address controversial subject matter, context, and meaning in various worlds of art. However, it is significant that, as in this case, language arts teachers are often better prepared than art teachers to deal with controversy in the curriculum, because, unlike visual arts teachers, they have developed written policies to defend the inclusion of controversial literature in the curriculum. Art teachers should take note.

A discipline-based approach to art education has the potential to make textbooks and other learning materials nearly as common in art education as they are in other curriculum areas. Educators should examine these materials for manifestations of bias, particularly for stereotyping, omissions, and biased language usage. Although no one should think of him- or herself as more civilized than others, in art education, as I have noted, some writers and teachers still do discriminate and think of themselves and their culture as superior to others.

Because Western traditions are so firmly entrenched, the "multiculturalizing" of art history texts will proceed slowly, but it is happening (see Addiss and Erickson, 1993). For example, Bersson's (1991) introductory art history and art criticism text, *Worlds of Art*, is based upon both formalist and contextualist approaches to understanding fine and popular art. Although this text still focuses primarily on Western traditions, Bersson does include many non-Western examples and specifically discusses the work of African Americans, Native Americans (First Nations peoples), and women.

Conclusion

In searching for commonalities in the roles and functions of art across cultures, art educators cannot represent all cultures, but, as I have shown in this chapter, they can still be multicultural in their approaches to the art curriculum. They can start by focusing on a known culture, expand to multiple cultures, and go on to consider art as a means of social and cultural change. The art disciplines provide the lenses they need to do so. The disciplines can be used singly or in overlapping combinations to answer aesthetic and critical questions: How do we identify "art that matters" in a given society? How are the arts used by a particular group? How does art educate and socialize? How do artists or performers structure both what they say and how

they say it? What are the roles and influences of the artist? How are the arts, the economy, and social organizations related? How are the answers to all these questions common across cultures?

Art education in a pluralistic society requires study of both the aesthetic and the social. If art history, aesthetics, and art criticism are to be related to meaningful art production, students will need to study artists from a variety of cultures who, through their work, have been cultural maintainers, social therapists, propagandists and catalysts of social change, mythmakers, magicians, enhancers, and decorators. Students can use their own art for these same purposes.

Designing and Implementing a Curriculum for Multicultural Art Education

This monograph is not about adding on; it is about restructuring. I have not included sample lessons and units for two reasons. First, because I ask teachers, advisers, curriculum coordinators, museum educators, and art education students to reconceptualize the whole nature of art and education in a culturally diverse society, there is a danger that individual generic units and lesson plans could be used as only partial, Band-Aid solutions. Like even the best of the existing material discussed in Chapter 4, individual lessons and units cannot be simply "lifted" and added on to existing programs. Second, different communities may require different ways, and different examples, to teach the broad themes addressed here and to reach the same goals and objectives.

By now, the reader should have a fairly good idea about what some of the goals, objectives, and themes of multicultural art education should be. However, there are some further factors to consider before the planning and implementation of an effective local curriculum can begin. Chapter 4 addressed the *content* of a meaningful and multicultural art education program. In this chapter, I consider the *structuring* and *sequencing* of multicultural art education curricula, as well as the *implementation* and *evaluation* of such programs. Up to this point, I have advocated general and universal goals and objectives

centering on the *why* of art. To reach these general goals, however, as well as to involve diverse groups and individuals effectively in a truly multicultural art education, educators may need to make decisions based on their own local contexts.

LOCAL CONCERNS

Stuhr, Petrovich-Mwaniki, and Wasson (1992) follow a number of curriculum and multicultural theorists in advocating a local art approach to the selection of learning activities. I am not opposed to using such an approach as a starting point, as long as educators keep larger overall goals in mind and seek to broaden the perspectives of all students. Stuhr et al. suggest that educators can explore the following aspects of the local context to generate material for relevant classroom practice:

- the history of the local area

- the cultural, social, political, religious, and economic factors that impinge upon it

- physical and cultural environmental influences

- demographic factors (population area break-

downs, population shifts)

- local values and belief systems (especially those that pertain to education and art)

- social-cultural/ethnic groups (breakdown, dominance)

- individual differences (age, gender, sexual orientation, exceptionalities)

- artistic/aesthetic production and resources (p. 20)

As these authors state, "The learning that takes place in the multicultural curriculum must [first] be relevant to the students' own cultural artistic experiences" (p. 24). It is important to remember, however, that the overall aim is *multi*culturalism in the curriculum. In paying attention to local concerns, educators should not lose sight of the unifying element (that different groups make and use art for rather similar reasons) or fail to introduce monocultural communities to other worlds of art.

Sequencing a Multicultural Art Program

The National Art Education Association (n.d.), in its publication *Quality Art Education: Goals for Schools*, states that all schools should provide "a *sequential* program of art instruction that is balanced to include the study of aesthetics, art criticism, art history, and art production" (n.p.; emphasis added). Although

not as rigidly as implied by the drawing books of the late nineteenth century, art education has gradually been returning to stronger notions of sequential curricula and moving toward national standards for what young people should know and be able to do in the arts at particular points in their schooling. A developmental and incremental approach to art education is central to DBAE and should contribute to conceptual foundations for the thematic study and practice of art in multicultural societies. However, to think about scope and sequence only in terms of content, as is frequently done (e.g., covering the art of a few cultures in the primary grades, a few more in intermediate and middle school or junior high grades, with the art of a final few cultures "covered" in senior secondary grades), is extremely naive and shows little understanding of either the purposes of multicultural art education or the stages of human growth and development.

In art education there is a rich heritage of developmentally focused research in art making (some of it cross-cultural), as well as a growing interest in both how students begin to understand history and how they may move through various stages in responding to art (see Addiss and Erickson, 1993; Parsons, 1987). Curriculum developers should make use of this material in determining the readiness of students to study and to make art in ways that reinforce the tenets I have set forth in this monograph. Currently, relatively sophisticated students are able to see artworks as "cultural artifacts" and as parts of sociocultural systems (Parsons, 1987). However, if educators deliberately teach toward this goal, as I am

suggesting they do, there is absolutely no reason such realizations should be the exclusive accomplishment of students at higher grade levels. In a multicultural society, art educators at all grade levels should teach about the functions and roles of art across cultures, and thus such contextual perceptions should occur among students at earlier ages. As I have suggested in Chapter 3, students at various levels can be asked to find, research, and discuss cross-cultural examples of art by makers who have become ascribers of meaning and/or status, catalysts of social change, enhancers and decorators, interpreters, magicians, mythmakers, propagandists, recorders of history, sociotherapists, storytellers, and teachers. Some of these activities, such as looking cross-culturally at artists as decorators, interpreters, and storytellers, can certainly begin in kindergarten. I suggest some possible starting points below.

LEVEL I
(PRIMARY GRADES/LOWER ELEMENTARY)

By the age of 5, children have formed attitudes about themselves and their peers, and they are beginning to develop cultural awareness (Smardo and Schmidt, 1983). Children quickly learn the prevailing social attitudes toward ethnic and other differences. Beginning in kindergarten, it is important for students to learn that art is made by women and men in all cultures, and that this has been true throughout history. Even very young children can, to some extent, contemplate and imagine the functions and roles of art in various societies.

Children in the primary grades typically enjoy making and looking at art, and appreciate art works in personal and concrete ways, e.g., favorite color, appealing subject matter. . . . Although their interpretations of art can be insightful, their grasp of artistic symbol systems . . . [may be] too limited [for them] to . . . engage in complex aesthetic inquiry. (Lankford, 1992, p. 37; based on Gardner, 1990; Gardner and Perkins, 1989)

According to Parsons (1987), students at this level hold nonjudgmental, nondiscriminatory views of art. Consequently, although their views can be highly personal, young children may be very open to considering the art of many cultures, particularly if it is not too historically remote. What is known, local, and familiar is a good starting point. For some time, public school art educators have believed that young children should work with a wide variety of art media and experience a number of ways to make art. Young children should also have opportunities to talk about many different kinds of art, from a variety of cultures and many time periods. Kindergarten children are certainly not too young to spend some time studying different artists and the contexts in which they work, especially at the local level.

Primary-age students can listen to stories about art and artists from a variety of cultures and can make their own art to tell and to illustrate stories. Multicultural approaches to art education may both challenge and make use of Piaget's developmental concepts. For example, Egan (1979) questions the notion that children need to begin with

what is known and move outward. He believes that development moves in the opposite direction, with the self being known last, and he posits that it is the most abstract of ideas that appeal to children in early childhood—opposites like good and evil, weak and strong, cowardly and courageous. Egan asserts that this "mythic state" should be what characterizes the early childhood curriculum. Accordingly, teachers would teach through stories, experiences, and narratives that engage children's interest in these abstract bipolar opposites, which are reflected in the art of many cultures. Like Piaget, Egan places the motivation for learning within the child. He wants to regain the imaginative and the poetic as part of the foundation for future learning (see Egan, 1991). As we are beginning to see in some young children's picture books, looking for the imaginative and the poetic in the art of other cultures can provide a fascinating introduction to art education.

Young children can also learn some basic art terms and concepts that can be used across cultures and can begin to distinguish and recognize works from a variety of cultures in different media. Broad-based social understanding becomes possible as children begin to understand that diverse groups of people make art for a similar variety of reasons.

Primary-age students can see and describe what is obvious or intrinsic in the art being discussed: subject, color, texture, and so on. McFee and Degge (1980) suggest that young children, and also older students, should "describe how artists [from a variety of cultures] repeat sizes, colors, shapes, or forms and textures to make order in an art work"

(p. 376). They also suggest that primary-age children should be able to "describe how objects with similar uses are made differently by people from different cultures" (p. 379).

It is always important for children to draw and otherwise take note of cultural objects. Also, as they progress in their art education, they should be visiting museums and other places where they can have many different encounters with art (broadly defined).

LEVEL 2 (INTERMEDIATE AND UPPER ELEMENTARY GRADES)

Parsons (1987) has noted that by the time they reach the upper elementary grades, European American students value skill, realism, and beauty. Little work has been done, however, with students from other cultural backgrounds of similar ages. Lankford (1992), again relying on research reported by Harvard University's arts education-related Project Zero (Gardner, 1990; Gardner and Perkins, 1989), posits that upper elementary students are aware that art can express ideas and emotions and that they are capable of pondering artistic motives. He suggests the use of "vivid cases" (e.g., puzzles and imaginary scenarios) to get older elementary students "thinking about the concept of art and about the nature of artistic expression" (p. 43).

At this level, students can make art for a purpose and thus identify with other artists in all cultures who use art for rather similar reasons. They can be encouraged to ask conceptually oriented

questions about art from many cultures. How was something made? Why was it made? Fitzpatrick (1992) suggests that children at this level must be guided by teachers "who know which answers can be found by students in material kept in the classroom or in simple conversations with artists" (p. 37). Upper elementary students can take notes at talks given by artists and others; use publications, films, and tapes for research on arts; interview community members about art; make short verbal presentations and write paragraphs or summaries about artworks; and make bulletin board displays showing commonalities in the roles and functions of art and artists in a variety of cultures.

LEVEL 3 (JUNIOR SECONDARY GRADES)

Students in the lower secondary grades are more aware of various aspects of aesthetic experience than are younger children. They may also accept differences of opinion more easily. Lankford (1992) cites research showing that young adolescents are especially concerned with the ways in which their own and others' artworks are able to convey meaning. They are increasingly able to recognize artistic styles and to relate art forms to various historical and cultural contexts, and can interpret symbols and compare and contrast ideas. Also, particularly useful from the perspective of multicultural education, they can speculate about origins and consequences, make suggestions and inferences, and consider alternatives. McFee and Degge (1980) suggest that students at this level are more visually aware than younger

students and can identify differences and similarities in artistic styles. These students can recognize that artists and designers in different cultures organize and emphasize particular elements of design for particular purposes.

By the time they reach this level, students are increasingly able to use photography and video as research tools for observing and describing the art forms of many cultures. They can become visual anthropologists, and, in addition to observing and describing, they should be able to consider the meanings of particular artworks and be able to modify their ideas about art as it functions in a variety of cultures. At this level, teachers should encourage more independent research and build upon students' curiosity. As Wilson (in press) notes, the tastes of middle-class high school students are broad. He describes an innovative and gamelike approach to collecting and understanding artworks that has been implemented at Colerain High School in suburban Cincinnati. The students seem not to be prejudiced against art from other cultures, as they actively seek to add reproductions of African, Hispanic, and Asian work to their collections.

Many students at this level are able to utilize relatively sophisticated art-related publications, and some may build impressive visual files (Fitzpatrick, 1992). These students may produce radio and television talk shows about aspects of art in a multicultural society, curate multicultural and thematic in-school museum exhibitions and produce accompanying catalogs, or produce video documentaries about various local art cultures.

By the senior secondary grades, aesthetic inquiry intermixes with historical, ethical, and political perspectives (Lankford, 1992). Students at this level question more and argue specific cases as lawyers might do in a courtroom. These students are increasingly able to use originating groups' standards when evaluating works of art. They are more capable than younger students of assuming the position of the other.

By this stage, McFee and Degge (1980) suggest, students can make more sophisticated written, oral, and/or visual seminar presentations to "analyze the role of the artist in different societies and see how the cultural values encourage and reward the artist" (p. 380). Students at this level can study the connections among art, artists, cultural organizations, and the roles and functions of various types of museums (Fitzpatrick, 1992). Increasingly, they can use out-of-school primary sources as they investigate what is common about art in a variety of contexts. As they develop, they become better "able to see and report more remote relationships among things" (McFee and Degge, 1980, p. 374). Students at this level are also increasingly able to maintain their independence when discussing the art of other people, despite peer pressure to conform.

Some students at this high grade level will be able to use their own art as communication and to address an audience. They may use murals, videos, illustrated publications, and group theme shows both to document the status quo and to move art education into the arena of social reconstruction.

LEARNING STYLES

Because prior experience conditions the ways in which a person learns, it is important for teachers and others to acknowledge and accommodate a variety of learning styles—particularly in a multicultural classroom. However, educators must also understand that all students from a particular ethnic group will not necessarily learn in a particular way. Culture is not defined only by ethnicity; it is much more complex than that. Reminiscent of McFee's (1961) early work is the following characterization of a possible art student provided by Stuhr et al. (1992): "A student may be five years old, female, Chinese (Taiwanese), hearing impaired, wealthy, and Buddhist" (p. 18). As McFee points out, such combinations of factors affect not only students' performance in the art classroom but how they approach learning in general—their learning style.

Cornett (1983) defines learning style as a consistent pattern of behavior in three areas: cognitive (concerned with processing, encoding, storage, and retrieval of information), affective (concerned with attention, motivation, and personality), and physical (concerned with perceptual modes, energy level, time preferences, and preferred learning environment). Rowntree (1982) defines learning style as "a student's habitual manner of problem-solving or thinking or learning, e.g., serialist or holistic, reflective or impulsive. The student may not be conscious of his style and may adopt different styles for different learning tasks or circumstances" (p. 155). A student's learning style or learning strategy, then, consists of "the student's general approach to a vari-

ety of learning tasks or . . . to his chosen way of tack-
ling a particular task" (p. 155).

Collier and Hoover (1987) and others have
identified and labeled a number of different learning
styles that may certainly be found in multicultural
classrooms.[12] However, being able to label a particu-
lar learning style is not very important by itself.
What is important is that educators recognize that
members of some cultures and subcultures employ
out-of-school teaching styles to develop certain
interests and aptitudes in children, so that instead
of ignoring these influences, they can reinforce and
utilize students' home-based and culturally unique
learning and communication styles. When teachers
attempt to impose learning styles on students,
schools can too often become institutions of social
adaptation rather than education.

McFee (1961, 1966; McFee and Degge, 1980)
and Stockrocki (1990) have made extensive studies
of cross-cultural learning styles and their implica-
tions for art education. Their work has been based
upon findings from the social and behavioral sci-
ences that show each person's potential to learn is
unique and depends upon past and present oppor-
tunities to use this potential. McFee pays significant
attention to the influence of culture in all of her
work, but she also stresses that we should attend as
much to individual as to group differences. There
is a fine line between being aware of some potential
effects of ethnicity on learning styles and expecting
a student from a particular ethnic group to behave
in a particular way. Educators should not view any
person as a cultural or ethnic stereotype, but should

respond to each learner as an individual for whom
ethnicity is only one of many personal characteris-
tics. However, research into the characteristics of
particular ethnic and cultural groups can help edu-
cators to become more sensitive to their students'
needs and values. For example, information on
different cultures' views of the appropriateness or
significance of silence, eye contact, and emotional
display, as well as differing perceptions of time, can
be useful to the art teacher. Educators also need to
acknowledge cultural change. As Spruill-Fleming's
(1991) research shows, numerous social and demo-
graphic changes have conditioned learning styles
in all cultural groups by greatly enlarging the
number of "urbanized, TV-addicted, fast-food/
fast-paced/fast-times oriented youngsters" (p. 8).

Longstreet (1978) asserts that there are three
factors teachers must address if they wish to
embrace and acknowledge diverse learning styles:
classroom atmosphere, relevance of information, and
appropriateness of materials. Much of this mono-
graph has addressed the need for art teachers to be
less ethnocentric in their definitions and under-
standing of art. Individual teachers also need to be
aware of their own learning styles, which in turn
affect their teaching styles, because these too have
been conditioned by ethnicity, education, life experi-
ences, religion, economic status, personality, and so
on. Kendall (1983) suggests that teachers can find
out about their own learning styles by examining the
same behavioral patterns in themselves that they
would examine in a student to identify the student's
learning style. Through such awareness, teachers

can recognize their own tendencies toward ethnocentrism and can examine their willingness to adapt their teaching styles to match the learning styles of their students.

Knowledge about art is important, but implementing any of the theory presented here requires a skilled teacher: one who asks good questions and is open-minded, diplomatic, confident, patient, organized, flexible, and able to interest and enthuse students. The teacher needs to be able to create a supportive learning environment for each student. Citing recent research, Hernandez (1989) posits that now, perhaps more than in the past, "most teachers intuitively employ multiple teaching approaches, and students demonstrate flexibility and adaptability in dealing with . . . modes of instruction" (p. 129). Although this may be more a desirable goal than a true reflection of current practice, it is a situation that seems particularly possible in an art classroom where the four disciplines (production, aesthetics, art criticism, and art history) encompass a variety of modes of instruction.

Certainly, as schools become more culturally diverse, art teachers need to consider alternative means of enabling students to learn and to express understanding in ways appropriate to their own cultural backgrounds and personalities. A discipline-based approach is ideal, because it allows students, individually and in groups, to learn about art in a variety of ways, using a variety of learning styles. They may use words, sort pictures, draw, or take photographs to describe, define, analyze, and classify art from many cultures. DBAE also provides opportunities, particularly through art making, for students to reflect, imagine, and construct personal meaning in other ways. For example, they might illustrate facets of "character" in the art they are studying through music, dance, or mime. We need to present students with opportunities to learn about the broad themes and functions of art within and across cultures, as outlined in Chapters 3 and 6, in terms of their own experiences and through a variety of different media and learning activities.

CONCLUSION: EVALUATING OUR APPROACHES TO MULTICULTURAL ART EDUCATION

As designers and implementers of multicultural approaches to art education, we need to ask a number of key questions about ourselves, our students, the curriculum, and the environments in which we teach (Etlin, 1988; Hernandez, 1989; Mehat, 1990).

For example, *what do we know about ourselves and our attitudes and beliefs about art?* Have we confronted prejudice and inequality? Are our views ethno- and/or egocentric? What do we know about the aesthetic attitudes and values of others who are different from us? How are these attitudes, values, and beliefs manifested when we teach children or interact with other educators? Do we celebrate diversity in art and in life, or does an acknowledgment of cultural pluralism appear to be tacked on, as an afterthought, to the things that we do, say, and believe? Do we demonstrate respect for cultures and backgrounds that are different from our own and firmly acknowledge that all groups can produce

and define cultural artifacts that are "excellent," and that, despite the many variations, in all cultures art is socially constructed and can exist for rather similar reasons? Are we committed to behaviors, dispositions, outlooks, and values that are multicultural?

Have we made genuine attempts to make visual art education relevant to all students? Do we provide classroom atmospheres in which our students' cultures and their art forms are recognized, shared, and respected? Are we knowledgeable about, and sensitive to, students' differing cultural backgrounds, values, traditions, and learning styles, and do we give students and community members opportunities to teach us what we don't know or understand about the arts of their cultures? Are *we* prepared to be students? Do learning and teaching operate in both directions in art classrooms and in galleries and museums? Do we involve parents and other community members in art learning activities? Whether we are teacher educators or teachers in schools or museums, we all need to ask: Who are our students? What are their cultural backgrounds? What do our students or museum visitors know about the art of others who are different from them? If we teach students from only one cultural group, this does not mean that we can ignore multiculturalism. In our increasingly global society, multicultural approaches are for everyone.

In our curricula, are the arts viewed as socially constructed? Are questions about art raised and framed in ways that encourage us to see that the arts may serve somewhat similar functions and roles in diverse cultures? For whom are the art curriculum and support materials we use designed? Is our instruction appropriately sequential and developmental? What attitudes and beliefs do particular art materials instill? Where are the gaps in terms of multicultural learning about the arts, and are they being addressed? What more can be done to reflect multicultural attitudes, help us see similarities, and build tolerance for diversity in the arts? Are we developing and actively encouraging the development of multicultural art curricula materials that are neither limited nor biased?

And, finally, *how is the art classroom learning environment constructed?* What is the emotional and psychological climate in the art classroom? Whose work is displayed? What student needs are attended to? Whose art is dominant? Why?

Multicultural art education programs need to be designed and implemented with attention to local concerns, appropriate sequencing of instruction, and individual and cultural learning styles. I discuss some possibilities for such design and implementation in the final chapter.

Art Education and Cultural Diversity: A Summary

In Chapter 1, I asked a number of questions. In the intervening chapters, I have provided some answers to those questions and, I hope, have shown that the questions and others like them are worth asking. The big questions asked here—Why do we make art? What is art for? How do we use art?—provide a direction. If art educators become sensitive to and aware of the functions and roles of art in society, they will be able to make art education more meaningful and relevant to a greater variety of students. In a culturally diverse society, some powerful and ethnocentric traditions have limited access to what many people consider art. We must broaden our definitions of art as we accept and appreciate diversity and seek to find some unity in that diversity. In this monograph I have argued that a broadly humanistic, culturally relative orientation will help us to do so.

A multicultural approach to art education is much more than just adding units on the art of a variety of cultures to the existing art curriculum. Answers to questions such as Why do we make art? help us to see that we all make art to perpetuate, challenge, decorate, and enhance our cultures. We need to focus on broad themes and functions of art that are cross-cultural, but that also give us an opportunity to include diverse, possibly local, examples of art related to selected themes. For example, the theme of why people make and/or use art can certainly be explored relative to cultures around the world. But such questions also demand local answers. How are the visual arts used in local places of worship? Are there women, or men, in a local quilting guild who will show their work and talk about why they quilt? How do students themselves use clothing or jewelry, or decorate their lockers or bedrooms, to make statements about themselves and the cultural groups to which they belong? What sorts of art are taught in local community centers or, in the case of something like graffiti, "on the street"? Why? How do different sectors of the community react, for example, to graffiti? There are many possibilities for seeing art's commonalities. Multiculturalism need not mean giving up Western canons; rather, it should mean seeing Western artistic traditions as only part of a larger number of traditions.

Art education should still focus on the "look" of things—"What is this work about?" and "Why does it look the way it does?" (Katter, 1991)—even as it becomes more like social studies education and seeks to have students understand art anthropologically in a diverse and pluralistic world. Although art critics may evaluate by making visual comparisons, it is not useful or valid to compare aesthetic qualities from different cultures using only Eurocentric or Western standards. Art educators need to recognize

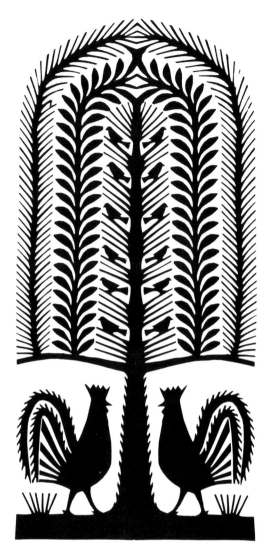

The Tree of Life, Leluja, Kurpie Region, Poland, ca. 1962. Cut paper, 9³/₄ × 4¹/₂ in. Courtesy of the Girard Foundation Collection in the Museum of International Folk Art, a unit of the Museum of New Mexico.

Chuang Hua (Window flowers for New Year), artist unknown, Shanxi Province, China, ca. 1950. Cut paper, 8¹/₂ × 4¹/₂ in. Courtesy of the Girard Foundation Collection in the Museum of International Folk Art, a unit of the Museum of New Mexico.

Finding some similarities: the tree of life in three cultures.

The Ann Robinson Quilt, Ann Robinson, Connecticut (?), 1813–14. Cotton and linen, 100 × 95 in. Courtesy of the Shelburne Museum.

that all cultures have definitions of quality and that members of all groups can point to examples of their own art that are excellent, mediocre, and poor. Failure to recognize this reality is both ethno- and egocentric. European American art educators may have less difficulty finding excellence in African or Asian art than in recognizing that a particular group can rate a given painting on black velvet as "excellent" or in attending to degrees of quality in skateboard decoration, but they need to learn that all are equally worthy of consideration as art.

Students need to learn to use the newer research techniques, or lenses, of art historians, aestheticians, and critics that require them to see artworks in their cultural contexts. Perspectives that come from cultural anthropology are particularly useful. Some possible themes for multicultural art curricula follow.

•Learning about how art is used for *continuity and stability* involves cross-cultural inquiry. This can be accomplished by having students study and make art designed to objectify and perpetuate particular cultural values—for example, art to give a presence to the gods. Or students might look for images in other cultures and in American subcultures of the 1990s that function in the same way as Norman Rockwell's *Saturday Evening Post* covers, to preserve and enhance the values of so-called Middle America.

•Understanding and using art to urge *change and improvement* and for social reconstruction can involve studying works that range from graffiti to Goya's paintings and prints. Related activities might involve filmmaking and collage or more traditional media, such as painting and sculpture. The challenge would be to make use of cross-cultural examples of protest art and to understand, for example, why some public sculpture that once stood for stability and supposedly enduring values, such as that found in the Soviet Union, has now been toppled.

•Understanding and using art to *enhance and enrich the environment* suggests a focus on design and the study of such cross-cultural aspects as decoration and embellishment in the built environment—for example, decorative elements in facades, clothing, and other cross-cultural artifacts.

•Understanding and using art to *celebrate* might involve looking across cultures to understand how and why the arts are used to celebrate and give meaning to key events in people's lives. For example, students might look at art associated with birth, coming of age, marriage, and death. Perhaps commercial North American greeting cards could be compared with art objects used to celebrate similar events in other cultures.

•Images of art that *record and tell stories* could be collected from a variety of cultures. Students could use their own art to tell stories. Some art forms and media particularly associated with storytelling, such as quilts, bas-relief friezes, picture books, totem poles, puppetry, tapestries, and murals, could be explored across cultures.

•The study and making of masks might provide one of many possible starting points from which to develop some understanding of the *ritualistic and therapeutic* uses of art, and of art as the expression of emotion.

•Art that *confers special meaning* and that is used for *identity and social status* can be researched cross-culturally. For example, notions of ownership and art as cultural capital might be explored in such diverse locations as Pacific Northwest aboriginal cultures and the salons of Europe. Jewelry, headdresses, clothing, scarification, insignia, and the cultural aspects of color theory represent some additional areas of fascinating cross-cultural study that could be linked to this theme.

•The above themes do not deny the celebration of art as *technical accomplishment*. It is important to continue to broaden our teaching collections to reflect a greater cultural range of accomplished work in all art media. Technical accomplishment and virtuosity can be explored across cultures. Students can study different technical traditions and perhaps even learn some skills that may be in danger of dying. The aims of such study should be cross-cultural respect and appreciation of all objects that are well made, of particular cultural definitions of the fitness of form, and of a job well done.

•It is also important to realize that sociocultural learning about art neither denies nor diminishes the notion of art for *aesthetic enjoyment*. It is my fervent hope that in addition to both gaining an understanding of and experiencing meaningful participation in the arts, teachers and students will enjoy and appreciate the arts of many different cultures.

The utopian goal of a pervasive multicultural approach to education can probably never be achieved without a major restructuring of society itself, but art education that is multicultural, sequential, and developmental, and that acknowledges diverse learning styles, can help us to see similarities in the roles and functions of art across cultures and can be an agent for positive social change. In this monograph I have suggested some ways in which we can implement change and enrich discipline-based art education theory and practice. As a beginning, we need to acknowledge changes in the art disciplines themselves. Art production, aesthetics, art criticism, and art history are all becoming more socioculturally oriented. Change is happening, but, as someone said at a multicultural art education conference I recently attended, "we're all in the same book, but we're not [yet] all on the same page."[13]

Art needs to be, and to be seen as, a potent aspect of all cultural life. People are increasingly leading multicultural lives. Multicultural societies desperately need visions, goals, ideals, and aspirations to replace the shallow materialism that can so easily suffocate spiritual lives.[14] Art can be especially affirming, and, as Juhani Pallasmaa (1990), a Finnish architect, notes, it can "enable us to experience the world and our own lives on a level of intensity, articulation, and depth which would otherwise be

THEORY INFORMS PRACTICE

A number of Vancouver area teachers designed specific learning activities for their own classrooms after being introduced to the theme categories outlined in this chapter. The Lower Mainland of British Columbia is a rapidly growing multicultural region with many opportunities for the study of art across cultures.

•As part of a summer course in art education and cultural diversity held at the University of British Columbia in 1994, a group of elementary and secondary school teachers studied the art of people different from, but in many ways similar to, themselves. They looked for common ways in which the visual arts were used to celebrate major events in the lives of Canadians from Central and South America, Chinese Canadians, Indo-Canadians, Italian Canadians, and Persian Canadians. Members of these communities were extremely enthusiastic and hospitable resource persons. Inquiries that began in stores and at worship services frequently ended with shared meals in private homes. Future classes will be looking at the art of other groups in the city. Perhaps these will be defined less by ethnicity and more by other shared traits, but again the teachers will be able to demonstrate for their students that we all use art to bolster and reinforce our cultural values.

•Some of these teachers encouraged older children to examine *arpilleras* from Peru and Chile for both their social content and methods of construction. The power of the AIDS Memorial Quilt was examined through a picture book and slides. Finally, a visit was made to an exhibition by a local contemporary quilt maker who used stitched fabric to say things about the lives of girls and women. After a discussion about art and social change, students were challenged to use fabric collage to make their own thoughtful and provocative artistic statements.

•A group of grade 7 students explored the Vancouver built environment. The students looked for a variety of cultural influences in architectural decoration. One specific task they were given was to draw and photograph columns and capitals in the downtown area that were not Doric, Ionic, or Corinthian.

•"Art for celebration" was a dominant theme in the many visual references that teachers collected from *National Geographic* and other magazines. In British Columbia, much primary art education centers on

holiday themes, and without a rich variety of visual resources, it is no wonder that much art learning in the past has been trite. Vancouver area teachers were enthusiastic about the possibilities of a discipline-based approach, particularly if commercially produced art print series would be available.

•Because of their focus on language arts in the primary grades, some teachers related multicultural art learning to children's picture books. Two teachers with access to wonderful collections of books looked at versions of the Cinderella story in Western and Eastern Europe, China, India, and indigenous America. The "look" of the different illustrations assumed particular importance, and students further explored some of the illustration techniques. Another teacher had intermediate-age students learn about puppetry as a way to tell stories of the triumph of good over evil and to explore such concepts as weak and strong, and cowardly and courageous, across cultures. Students were introduced to a variety of methods to construct puppets, and they developed their own stories of good and evil.

•For a group of grade 4 students, hockey masks and glossy magazine makeup advertisements led to a study of transformation masks in the First Nations collection at the University of British Columbia's Museum of Anthropology. Back at school, the students developed original papier-mâché masks that transformed their wearers without either appropriating or diminishing Native American culture.

•A high school art teacher in an inner-city school designed a unit on tattooing. The teacher had collected an amazing variety of visual material and had interviewed local tattooists. Aesthetic and social-status aspects of tattooing were examined in contemporary urban cultures and a variety of ethnic groups. The very streetwise students, many of whom already had tattoos, became researchers, learning as much as they could about tattooing across cultures. A particularly poignant cross-cultural relationship was drawn between two of the images the teacher had collected for classroom use. Both were of white European males using different art forms for social status. In one, an aristocratic executive was surrounded by his gold-framed "old masters"; in the other, a construction worker proudly displayed his heavily tattooed arms and back.

Some of these activities are, of course, very tentative beginnings. Some are add-ons. Not all have incorporated a new approach to the art curriculum, but they do suggest possible starting points. They are presented here not because they should be copied, but because they might inspire others.

beyond our scope of understanding and experience" (p. 28). This is perhaps the timeless purpose of all art: Western art, Eastern art, African art, African American art, First Nations art, women's art, folk art, children's art, gay and lesbian art, the art of galleries and museums, and the public art of the streets: to enhance our sense of being, not only here and now, but also in a continuum of time and traditions. When effectively taught, art can endow our sense of being with sometimes nearly inexplicable meaning. As one observer has said of multiculturalism: "It's here . . . the questions are: How do we organize, how do we deal with it, how do we enjoy it?" (in Cembalest, 1991, p. 109).[15] I have attempted to help art teachers and others sort out their own philosophies and classroom practices in an area that has been both ill defined and controversial. Multiculturalism is in vogue at present. Together with the issue of assessment, debates concerning multiculturalism will probably occupy much of art educators' attention in the final years of the twentieth century. However, the issues discussed in this monograph are more than a matter of fashion. Education trends will change and research agendas will shift, but art teachers in public institutions will still need to educate all students for a multicultural future.

Notes

1. In discipline-based art education (DBAE), which has been widely embraced in North America, students study art from the perspectives of four disciplines: aesthetics, art criticism, art history, and art production.

2. Although I use the term *art* throughout this monograph and embrace the concept of cultural relativism (discussed in a later section), I acknowledge the problematic nature of my decisions regarding this terminology. Terms such as *multiculturalism, cultural pluralism,* and *cultural diversity* are often used interchangeably. In the context of this monograph, *cultural diversity* is the term that best describes current North American society; the sort of society toward which we should strive is one that holds a value commitment to multiculturalism or cultural pluralism.

3. I have found works by Banks (1991), Bennett (1990), Garcia (1982), Gollnick and Chin (1986), Grant (1992), Grant and Sleeter (1986), Hernandez (1989), Lynch (1990), Sleeter (1991), Sleeter and Grant (1987, 1988), and Tiedt and Tiedt (1990) to be useful in my formulation of ideas for this occasional paper.

4. This monograph makes use of and extends some of my earlier work. See particularly Chalmers (1971, 1973, 1978, 1981, 1984, 1985, 1986, 1987a, 1987b, 1992a, 1992b, 1992c) and Mullen and Chalmers (1990).

5. An earlier version of this chapter appeared as an article titled "The Origins of Racism in the Public School Art Curriculum" (Chalmers, 1992c). It is revised and reprinted here with permission from the National Art Education Association.

6. These stereotypes persisted in many publications produced by whites. For example, consider the entry at "Negro" in the first American edition of the *Encyclopedia Britannica* (1798):

> *a name given to a variety of the human species, who are entirely black, and are found in the Torrid zone, especially in that part of Africa which lies within the tropics. . . . Vices the most notorious seem to be the portion of this unhappy race: idleness, treachery, revenge, cruelty, impudence, stealing, lying, profanity, debauchery, nastiness, and intemperance, are said to have extinguished the prin-ciples of natural law, and to have silenced the reproofs of conscience. They are strangers to every sentiment of compassion, and are an awful example of the corruption of man when left to himself. (p. 794)*

7. Currently, Vesta A. H. Daniel, at Ohio State University, is compiling a multicultural curriculum register.

8. In her editorial introduction to the fall 1990 issue of the *Journal of Multicultural and Cross-Cultural Research in Art Education*, Degge agonizes over the use of terms such as "black, white, Afro-American, American, Appalachian, American Indian, Native American, Ethnic Fijian, [and] Indo-Fijian." Obviously, decisions on names and labels are important. I advocate using the term or terms preferred by most members of the group whose art is being studied. It is also useful for students to consider how changing nomenclature reflects changing attitudes.

9. See the discussion of Fred Wilson's work in Getty Center for Education in the Arts (1993).

10. Within a diverse society, exhibition policy has several dimensions. Some of the issues involved are profiled in a number of books that have substantial curriculum implications; for example, see Karp and Lavine (1990), Karp, Kraemer, and Lavine (1992), Messenger (1989), and Price (1989).

11. *Curricular desegregation* is a term that was coined by James Boyer (see Boyer and Boyer, 1975).

12. Many different learning styles have been described by researchers, who have given them such names as field independence, field sensitivity, low tolerance, reflective, impulsive, broad categorizer, narrow categorizer, high persistent, low persistent, high anxiety, low anxiety, internal locus of control, and external locus of control.

13. This comment was made by an audience member at the final plenary session of the Getty Center for Education in the Arts's Issues III Seminar, Cultural Diversity and DBAE, Austin, TX, August 1992 (see Getty Center for Education in the Arts, 1993).

14. Balfe and Wyszomirski (1990) studied nonparticipants in the arts—that is, individuals who do not find art meaningful. They found that nonparticipants (in New Jersey) were primarily among those people no longer embedded in ethnic or regional subcultures, but not yet assimilated into the majority culture.

15. These questions are asked by Henry Hopkins, a university art department chair and gallery director, quoted in Cembalest's (1991) article.

References

Addiss, S., and Erickson, M. 1993. *Art history and education*. Urbana: University of Illinois Press.

Akbar, S. 1993. *The Nehru Gallery National Textile Project* [Pamphlet describing the South Asian arts education initiative]. London: Victoria and Albert Museum.

Alexander, K., and Day, M. (eds.). 1991. *Discipline-based art education: A curriculum sampler*. Los Angeles: Getty Center for Education in the Arts.

Amnesty International. 1991. *Free expression: The Amnesty International art education pack*. London: Amnesty International, British Section.

Anderson, R. L. 1990. *Calliope's sisters: A comparative study of philosophies of art*. Englewood Cliffs, NJ: Prentice Hall.

Archer, B. 1978. The arts in education. In *The arts in cultural diversity* [Proceedings of the INSEA 23rd World Congress]. Sydney: Holt, Rinehart & Winston.

Association for Supervision and Curriculum Development. 1992. *Resolutions* 1992. Alexandria, VA: Association for Supervision and Curriculum Development.

Balfe, J. H., and Wyszomirski, M. J. 1985. *Art, ideology and politics*. New York: Praeger.

Balfe, J. H., and Wyszomirski, M. J. 1990. *The political consequences of non-participation in the arts*. Paper presented at the International Sociological Association 12th World Congress of Sociology, "Sociology for one world: Unity and diversity," Madrid.

Banks, J. A. 1989. Integrating the curriculum with ethnic content: Approaches and guidelines. In J. A. Banks and C. A. McGee-Banks (eds.), *Multicultural education issues and perspectives*. Boston: Allyn & Bacon.

Banks, J. A. 1991. *Teaching strategies for ethnic studies*. Boston: Allyn & Bacon.

Banks, J. A. 1992. Multicultural education: For freedom's sake. *Educational Leadership* 49(4): 32–36.

Banks, J. A., and McGee-Banks, C. A. (eds.). 1989. *Multicultural education issues and perspectives*. Boston: Allyn & Bacon.

Barkan, M. 1953. Art and human values. *Art Education* 6(3): 1–2.

Barrett, T., and Rab, S. 1990. Twelve high school students, a teacher, a professor and Robert Mapplethorne's photographs: Exploring cultural difference through controversial art. *Journal of Multicultural and Cross-Cultural Art Education* 8(1): 4–17.

Becker, H. 1976. Art worlds and social types. *American Behavioral Scientist* 19(6): 703–718.

Becker, H. 1982. *Art worlds*. Berkeley: University of California Press.

Bennett, C. I. 1990. *Comprehensive multicultural education: Theory and practice*. Boston: Allyn & Bacon.

Berger, J. 1972. *Ways of seeing*. Harmondsworth, UK: Penguin.

Bersson, R. 1991. *Worlds of art*. Mountain View, CA: Mayfield.

Bissoondath, N. 1993. *The innocence of age*. Toronto: Penguin.

Blandy, D., and Congdon, K. (eds.). 1987a. *Art in a democracy*. New York: Teachers College Press.

Blandy, D., and Congdon, K. 1987b. Introduction. In D. Blandy and K. Congdon (eds.), *Art in a democracy*. New York: Teachers College Press.

Blau, J. R. 1988. Study of the arts: A reappraisal. *Annual Review of Sociology* 14: 269–292.

Bolt, C. 1971. *Victorian attitudes to race*. Toronto: Routledge & Kegan Paul/University of Toronto Press.

Bourdieu, P. 1984. *Distinction* (trans. R. Nice). Cambridge: Harvard University Press. (Original work published 1980.)

Bowles, S., and Gintis, H. 1976. *Schooling in capitalist America*. New York: Basic Books.

Boyer, J., and Boyer, J. 1975. *Curriculum and instruction beyond desegregation*. Manhattan, KS: Ag.

Brantlinger, P. 1990. Pensee sauvage at the MLA: Victorian cultural imperialism then and now. *Victorian Newsletter* 77(Spring): 1–4.

British Columbia Ministry of Education. 1993. *The intermediate program policy: Grades 4 to 10*. Victoria: British Columbia Ministry of Education.

Bullard, S. 1992. Sorting through the multicultural rhetoric. *Educational Leadership* 49(4): 4–7.

Callen, A. 1979. *Angel in the studio: Women in the arts and crafts movement 1870–1914*. London: Astragal.

Cembalest, R. 1991. Goodbye Columbus? *Artnews* 91(8): 104–109.

Chalmers, F. G. 1971. *Toward a theory of art and culture as a foundation for art education*. Unpublished Ph.D. dissertation, University of Oregon.

Chalmers, F. G. 1973. The study of art in a cultural context. *Journal of Aesthetics and Art Criticism* 32(4): 249–256.

Chalmers, F. G. 1978. Teaching and studying art history: Some anthropological and sociological considerations. *Studies in Art Education* 20(1): 18–25.

Chalmers, F. G. 1981. Art education as ethnology. *Studies in Art Education* 23(3): 6–14.

Chalmers, F. G. 1984. Artistic perception: The cultural context. *Journal of Art and Design Education* 3(3): 279–289.

Chalmers, F. G. 1985. Art as a social study: Theory into practice. *Bulletin of the Caucus on Social Theory and Art Education* 5(1): 40–50.

Chalmers, F. G. 1986. Enquiry into cultural identity and realization through the arts: A review of literature. *Journal of Art and Design Education* 5(1–2): 187–193.

Chalmers, F. G. 1987a. Beyond current conceptions of discipline-based art education. *Art Education* 40(6): 58–61.

Chalmers, F. G. 1987b. Cultural versus universal understanding of art. In D. Blandy and K. Congdon (eds.), *Art in a democracy*. New York: Teachers College Press.

Chalmers, F. G. 1990. South Kensington in the farthest colony. In D. Soucy and M. A. Stankiewicz (eds.), *Framing the past: Essays on art education.* Reston, VA: National Art Education Association.

Chalmers, F. G. 1992a. DBAE as multicultural education. *Art Education* 45(3): 16–24.

Chalmers, F. G. 1992b. Multicultural art education: It's more than making totem poles out of the insides of toilet rolls. *British Columbia Art Teachers Association Journal for Art Teachers* 32(1): 7–9.

Chalmers, F. G. 1992c. The origins of racism in the public school art curriculum. *Studies in Art Education* 33(3): 134–143.

Chanda, J. 1993. *African arts and culture.* Worcester, MA: Davis.

Child, I., and Siroto, L. 1965. BaKwele and American esthetic evaluations. *Ethnology* 4: 349–360.

Clark, G. 1990. Art in the schizophrenic fast lane. *Art Education* 43(6): 8, 24.

Clarke, I. E. 1885. *Art and industry. Instruction in drawing applied to the industrial and fine arts as given in the colleges of agriculture and the mechanic arts, and in the public schools and other public educational institutions in the United States (Part 1): Drawing in public schools.* Washington, DC: Government Printing Office.

Clifford, J. 1988. *The predicament of culture: Twentieth century ethnography, literature and art.* Cambridge: Harvard University Press.

Coleman, L. V. 1939. *The museum in America: A critical study.* Washington, DC: American Association of Museums.

Collier, C., and Hoover, J. J. 1987. *Cognitive learning strategies for minority handicapped students.* Lindale, TX: Hamilton.

Collins, G., and Sandell, R. 1992. The politics of multicultural art education. *Art Education* 45(6): 8–13.

Cope, E. D. 1887. *The origin of the fittest.* New York: Macmillan.

Cornett, C. E. 1983. *What you should know about teaching and learning styles.* Bloomington, IN: Phi Delta Kappa Educational Foundation.

Crane, W. 1925. *The bases of design.* London: G. Bell & Sons.

Daniel, F., and Manley-Delacruz, E. 1993. Art education as multicultural education: The underpinnings of reform [Editorial]. *Visual Arts Research* 19(2): v–ix.

Daniel, V. 1990. Introduction. In B. Young (ed.), *Art, culture, and ethnicity.* Reston, VA: National Art Education Association.

Danto, A. C. 1981. *The transformation of the commonplace.* Cambridge: Harvard University Press.

Degge, R. M. 1990. Editorial. *Journal of Multicultural and Cross-Cultural Research in Art Education* 8(1): 1–2.

DePillars, N. M. 1990. Multiculturalism in visual arts education: Are America's educational institutions ready for multiculturalism? In B. Young (ed.), *Art, culture, and ethnicity.* Reston, VA: National Art Education Association.

Detlefsen, J. 1991. *A briefing paper on multicultural art education and diversity issues as revealed through Prairie Visions, a Getty Center regional grantee.* Unpublished manuscript.

DiMaggio, P., and Ostrower, F. 1990. Participation in the arts by black and white Americans. *Social Forces* 8(3): 753–778.

Dissanayake, E. 1984. Does art have selective value? *Empirical Studies of the Arts* 2(1): 35–49.

Dissanayake E. 1988. *What is art for?* Seattle: University of Washington Press.

Dissanayake, E. 1992. *Homo aestheticus: Where art comes from and why.* New York: Free Press.

Dubin, S. C. 1986. Aesthetic production and social control. *Social Forces* 64(3): 667–688.

Dufrene, P. 1994. A response to Mary Erickson: It is time to redefine "Western" and "non-Western"; or, When did Egypt geographically shift to Europe and Native Americans become non-Western? *Studies in Art Education* 35(4): 252–253.

Duncum, P. 1990. Clearing the decks for dominant culture: Some first principles for a contemporary art education. *Studies in Art Education* 31(4): 207–215.

Efland, A. 1976. The school art style: A functional analysis. *Studies in Art Education* 17(2): 37–44.

Egan, K. 1979. *Educational development.* New York: Oxford University Press.

Egan, K. 1991. *Primary understandings: Education in early childhood.* New York: Basic Books.

Eisner, E. W. 1988. Structure and magic in discipline-based art education. *Journal of Art and Design Education* 7(2): 185–196.

Encyclopedia Britannica. 1798. *Encyclopedia Britannica* (3rd ed.). Philadelphia: Encyclopedia Britannica.

Etlin, M. 1988. To teach them all is to know them all. *NEA Today* 6(10): 10–11.

Fehrs-Rampolla, B. 1989. *Accepting diversity: A multicultural art approach.* Holmdell, NJ: Holmdell Township Board of Education.

Feldman, E. B. 1970. *Becoming human through art.* Englewood Cliffs, NJ: Prentice Hall.

Feldman, E. B. 1994. [Letter to the editor]. *Art Education* 47(2): 8.

Fine, G. 1977. Popular culture and social interaction: Production, consumption, and usage. *Journal of Popular Culture* 11(3): 453–466.

Fitzpatrick, V. L. 1992. *Art history: A contextual inquiry course.* Reston, VA: National Art Education Association.

Flores Fratto, T. 1978. Undefining art: Irrelevant categorization in the anthropology of aesthetics. *Dialectical Anthropology* 3(2): 129–138.

Folgarait, L. 1985. Art-state-class: Avant-garde art production and the Russian Revolution. *Art Magazine* (December): 69–75.

Ford, C., Prothro, T., and Child, I. 1966. Some transcultural comparisons of esthetic judgement. *Journal of Social Psychology* 68(1): 19–26.

Fraser, P., and Stevenson, C. 1990. *Problems of making in response to Aboriginal art and design.* Paper presented at the Australian Institute of Art Education Conference, Adelaide.

Freedman, K. 1991. Recent theoretical shifts in the field of art history. *Art Education* 44(6): 40–45.

Freedman, K., Stuhr, P., and Weinberg, S. 1989. The discourse of culture and art education. *Journal of Multicultural and Cross-Cultural Research in Art Education* 7(1): 38–55.

Garcia, R. L. 1982. *Teaching in a pluralistic society: Concepts, models, strategies.* New York: Harper & Row.

Gardner, H. 1990. *Art education and human development.* Los Angeles: Getty Center for Education in the Arts.

Gardner, H., and Perkins, D. (eds.). 1989. *Art, mind and education.* Urbana: University of Illinois Press.

Gerbrands, A. 1957. *Art as an element of culture, especially in Negro Africa.* Leiden, Netherlands: E. J. Brill.

Getty Center for Education in the Arts. 1993. *Discipline-based art education and cultural diversity.* Santa Monica, CA: J. Paul Getty Trust.

Gibson, M. A. 1976. Approaches to multicultural education in the United States: Some concepts and assumptions. *Anthropology and Education Quarterly* 14(4): 7–18.

Gollnick, D. M., and Chin, P. C. 1986. *Multicultural education in a pluralistic society.* Columbus, OH: Charles E. Merrill.

Gordon, E. A. 1992. Murals: Art or mere sociology? *S.P.A.R.C.plug* 2(3): 5, 14.

Gotshalk, D. 1962. *Art and the social order.* New York: Dover.

Gould, S. J. 1981. *The mismeasure of man.* New York: W. W. Norton.

Grant, C. (ed.). 1992. *Research and multicultural education: From the margins to the mainstream.* Philadelphia: Falmer.

Grant, C., and Sleeter, C. 1986. Educational equity: Education that is multicultural and social reconstructionist. *Journal of Education Equity and Leadership* 6(2): 105–118.

Grigsby, E. 1977. *Art and ethnics: Background for teaching youth in a pluralistic society.* Dubuque, IA: William C. Brown.

Grigsby, E. 1991. *Contributions of minority art educators to American art education.* Paper presented at the National Art Education Association Conference, Atlanta, GA.

Griswold, W. 1987. The fabrication of meaning: Literary interpretation in the United States, Great Britain and the West Indies. *American Journal of Sociology* 92(1): 107–117.

Hamblen, K. 1986. A universal-relative approach to the study of cross-cultural art. *Journal of Multicultural and Cross-Cultural Research in Art Education* 4(1): 69–77.

Hamblen, K. 1990. Beyond the aesthetic of cash-culture literacy. *Studies in Art Education* 31(4): 216–225.

Hamblen, K., and Galanes, C. 1991. Instructional options for aesthetics: Exploring the possibilities. *Art Education* 44(6): 12–24.

Hart, L. 1991. Aesthetic pluralism and multicultural art education. *Studies in Art Education* 32(3): 145–159.

Heard, D. 1989. A pedagogy for multiculturalizing art education. *Journal of Multicultural and Cross-Cultural Research in Art Education* 7(1): 4–20.

Hernandez, H. 1989. *Multicultural education: A teacher's guide to content and process.* Columbus, OH: Charles E. Merrill.

Hilliard, A. G., III. 1992. Why we must pluralize the curriculum. *Educational Leadership* 49(4): 12–16.

Hirsch, E. D., Jr. 1987. *Cultural literacy: What every American needs to know.* Boston: Houghton Mifflin.

Holloman, L. O. 1989. Self-esteem and selected clothing attitudes of black adults: Implications for counselling and development. *Journal of Multicultural Counselling and Development* 17(April): 50–61.

Iwao, S., and Child, I. 1966. Comparison of aesthetic judgements by American experts and by Japanese potters. *Journal of Social Psychology* 68(1): 27–33.

Iwao, S., Child, I., and Garcia, M. 1969. Further evidence of agreement between Japanese and American aesthetic evaluations. *Journal of Social Psychology* 71(1): 11–15.

Iwawaki, S., Eysenck, H., and Gotz, K. 1969. A new visual aesthetic sensitivity test (VAST): II. Cross-cultural comparison between England and Japan. *Perceptual and Motor Skills* 49(4): 859–862.

Janson, H. W. 1981. *A basic history of art.* New York: Prentice Hall/Abrams.

Jenkins, I. 1958. *Art and the human enterprise.* Hamden, CT: Archon.

Jones, O. 1856. *The grammar of ornament.* London: Day & Son.

Kadushin, C. 1976. Networks and circles in the production of culture. *American Behavioral Scientist* 19(6): 769–784.

Kaepler, A. 1976. Art. In D. Huner and P. Whitten (eds.), *Encyclopedia of anthropology.* New York: Harper & Row.

Kantner, L. 1983. Editorial. *Journal of Multicultural and Cross-Cultural Research in Art Education* 1(1): 4.

Karbusicky, V. 1968. The interaction between reality-work of art-society. *International Social Science Journal* 20(4): 644–655.

Karp, I., Kraemer, C. M., and Lavine, S. D. (eds.). 1992. *Museums and communities: Debating public culture.* Washington, DC: Smithsonian Institution Press.

Karp, I., and Lavine, S. D. (eds.). 1990. *Exhibiting cultures: The poetics and politics of museum display.* Washington, DC: Smithsonian Institution Press.

Katter, E. 1991. Meeting the challenge of cultural diversity. *Visual Arts Research* 17(2): 28–32.

Kendall, F. E. 1983. *Diversity in the classroom: A multi-cultural approach to the education of young children.* New York: Teachers College Press.

Kleinbauer, W. 1987. Art history in discipline-based art education. *Journal of Aesthetic Education* 21(2): 205–215.

Lanier, V. 1969. The teaching of art as social revolution. *Phi Delta Kappan* 50(6): 314–319.

Lanier, V. 1980. Six items on the agenda for the eighties. *Art Education* 33(5): 16–23.

Lankford, E. L. 1992. *Aesthetics: Issues and inquiry.* Reston, VA: National Art Education Association.

Leclerc, G. L. [Comte de Buffon]. 1785. The natural history of man. In G. L. Leclerc, *Natural history, general and particular* (2nd ed., Vol. 3) (trans. W. Smellie). London.

Le Vine, R., and Campbell, D. 1972. *Ethnocentrism: Theories of conflict, ethnic attitudes and group behavior.* New York: John Wiley & Sons.

Lindauer, M. 1990. Reactions to cheap art. *Empirical Studies of the Arts* 8(2): 95–110.

Linnaeus [von Linne], K. 1806. *A general system of nature through the three grand kingdoms of animals, vegetable, and minerals.* London.

Lloyd, B. 1992. [Letter to the editor]. *Art Education* 45(6): 7.

Lloyd, B. 1995. [Letter to the editor]. *Art Education* 48(2): 5.

Long, E. 1774. *A history of Jamaica.* London.

Longstreet, W. S. 1978. *Aspects of ethnicity: Understanding differences in pluralistic classrooms.* New York: Teachers College Press.

Lorimer, D. 1988. Theoretical racism in late-Victorian anthropology, 1870–1900. *Victorian Studies* 31(3): 405–430.

Lukacs, G. 1971. *History and class consciousness.* London: Merlin.

Lynch, J. 1990. *Multicultural curriculum.* London: Trafalgar Square.

Mann, D. 1977. Architecture, aesthetics, and pluralism: Theories of taste as a determinant of architectural standards. *Studies in Art Education* 20(3): 15–29.

Maquet, J. 1979. *Introduction to aesthetic anthropology.* Malibu, CA: Undena.

Maquet, J. 1986. *The aesthetic experience: An anthropologist looks at the visual arts.* New Haven, CT: Yale University Press.

Marsden, W. E. 1990. Rooting racism into the educational experiences of childhood and youth in the nineteenth and twentieth centuries. *History of Education* 19(4): 333–353.

Mason, R. 1988. *Art education and multiculturalism.* London: Croom Helm/Methuen.

McFee, J. K. 1961. *Preparation for art.* Belmont, CA: Wadsworth.

McFee, J. K. 1966. Society, art, and education. In *A seminar in art education for research and curriculum development.* University Park: Pennsylvania State University.

McFee, J. K. 1986. Cross-cultural inquiry into the social meaning of art: Implications for art education. *Journal of Multicultural and Cross-Cultural Research in Art Education* 4(1): 6–16.

McFee, J. K. 1988. Art in society. In H. Feinstein (ed.), *Issues in discipline-based art education: Strengthening the stance, extending the horizons.* Los Angeles: Getty Center for Education in the Arts.

McFee, J. K., and Degge, R. M. 1980. *Art, culture and environment: A catalyst for teaching.* Dubuque, IA: Kendall Hunt.

Mehat, I. 1990. Four approaches to multicultural education. In *Symposium on the fine arts in education—music, visual art, drama, dance—prompted by the new British Columbia schools curriculum "The year 2,000."* Burnaby, BC: Simon Fraser University.

Messenger, P. M. (ed.). 1989. *The ethics of collecting cultural property: Whose culture? Whose property?* Albuquerque: University of New Mexico Press.

Mogdil, S., Verma, G., Kanka, M., and Mogdil, C. (eds.). 1986. *Multicultural education: The interminable debate.* Philadelphia: Taylor & Francis.

Mosquera, G. 1993. The Marco Polo syndrome: Some problems around art and Eurocentrism. *Third Text* 21: 35–41.

Mullen, C., and Chalmers, F. G. 1990. Guest editorial: Culture, society, and art education. *Studies in Art Education* 31(4): 195–197.

Multiculturalism Canada. n.d. Multiculturalism education through art [Special issue]. *Multiculturalizing* 1(2).

Nakonechny, J. 1989. Cultural differences in the classroom. *MC multiculturalism/multiculturalisme* 12(2): 12–13.

National Art Education Association. n.d. *Quality art education: Goals for schools.* Reston, VA: National Art Education Association.

National Arts Education Research Center. 1990. *A framework for multicultural arts education.* New York: New York University.

National Council for Accreditation of Teacher Education. 1979. *Standards for accreditation of teacher education.* Washington, DC: National Council for Accreditation of Teacher Education.

National Education Association. 1989. [News item]. *NEA Today* 7(10): 4–5.

Nochlin, L., and Harris, A. S. 1971. *Women artists 1550–1950.* Los Angeles: Los Angeles County Museum of Art (distributed by Random House).

Oxfam. 1990. *Art and development education materials: Art against apartheid and antiracism and art in Britain and South Africa.* Oxford: Oxfam Education and Publications.

Pallasmaa, J. 1990. Integrating art into general education. Art, knowledge and reality: On the cultural significance of art. In J. Dobbs (ed.), *Music education: Facing the future.* Helsinki: International Society for Music Education.

Pankratz, D. 1987. Cultural diversity, arts policy, and arts education. *Journal of Multicultural and Cross-Cultural Research in Art Education* 5(1): 57–72.

Pankratz, D. 1992. *Multiculturalism and the arts: An analysis of the conceptual foundations and policy issues.* Unpublished Ph.D. dissertation, Ohio State University.

Pankratz, D. 1993. *Multiculturalism and public arts policy.* Westport, CT: Bergin & Garvey.

Parker, R., and Pollock, G. 1981. *Old mistresses: Women, art and ideology.* New York: Routledge & Kegan Paul.

Parsons, M. 1987. *How we understand art: A cognitive developmental account of aesthetic experience.* New York: Cambridge University Press.

Pearson, N. 1982. *The state and the visual arts.* Milton Keynes, UK: Open University Press.

Pindell, H. 1990. Art world racism—the glaring omission: Breaking the silence. *New Art Examiner* 18(2–3): 18–27, 50–51.

Pointon, M. 1986. *History of art.* London: Allen & Unwin.

Popkin, R. 1973. The philosophical basis of eighteenth-century racism. In H. E. Pagliaro (ed.), *Studies in eighteenth-century culture: Racism in the eighteenth century.* Cleveland: Press of Case Western Reserve University.

Poynter, E. J., and Head, P. R. 1885. *Classic and Italian painting.* London: Sampson, Low, Marston, Searle, & Rivington.

Price, S. 1989. *Primitive art in civilized places.* Chicago: University of Chicago Press.

Rabinow, P. 1986. Representations are social facts: Modernity and post-modernity in anthropology. In J. Clifford and G. E. Marcus (eds.), *Writing culture: The poetics and politics of ethnography.* Berkeley: University of California Press.

Rosenberg, H. 1959. *The tradition of the new.* New York: Horizon.

Rowntree, D. 1982. *A dictionary of education.* Totowa, NJ: Barnes & Noble.

Ryan, M. 1989. *Cultural journeys: 84 art and social studies activities from around the world.* Holmes Beach, FL: Learning Publications.

Scarr, M., and Paul, D. 1992. Art against racism. *British Columbia Art Teachers Association Journal for Art Teachers* 32(1): 32–37.

Schlesinger, A., Jr. 1991. The cult of ethnicity, good and bad. *Time* (July 8): 21.

Schwartz, J., and Exter, T. 1989. *American Demographics* (May).

Segall, M. H., Campbell, D. T., and Herskovits, M. J. 1966. *The influence of culture on visual perception.* New York: Bobbs-Merrill.

Shapson, S. 1990. An agenda for evaluating multicultural teaching. In V. D'Oyley and S. Shapson (eds.), *Innovative multicultural teaching.* Toronto: Kagan & Woo.

Sleeter, C. E. (ed.). 1991. *Empowerment through multicultural education.* Albany: State University of New York Press.

Sleeter, C. E., and Grant, C. A. 1987. An analysis of multicultural education in the United States. *Harvard Educational Review* 57(4): 421–444.

Sleeter, C. E., and Grant, C. A. 1988. *Making choices for multicultural education: Some approaches to race, class, and gender.* Columbus, OH: Charles E. Merrill.

Smardo, F. A., and Schmidt, V. 1983. Developing multicultural awareness. *Children and Today* 12(3): 23–25.

Smith, P. 1992. Commentary: The paradoxes of multiculturalism. *Journal of Aesthetic Education* 26(2): 95–99.

Spruill-Fleming, P. 1990. Linking the legacy: Approaches to the teaching of African and American art. In B. Young (ed.), *Art, culture, and ethnicity.* Reston, VA: National Art Education Association.

Spruill-Fleming, P. 1991. *Multicultural education and discipline-based art education: Toward a visionary future.* Unpublished manuscript (prepared for the Getty Center for Education in the Arts), California State University, Fresno.

Stockrocki, M. 1990. Issues in multicultural art education. In E. W. King and S. D. La Pierre (eds.), *Using the arts as an educational model for high-risk individuals.* Denver: University of Denver, School of Art.

Stross-Haynes, J. 1993. Historical perspectives and antecedent theory of multicultural art education: 1954–1980. *Visual Arts Research* 19(2): 24–34.

Stuhr, P. 1991. Contemporary approaches to multicultural art education in the United States. *International Society for Education through Art (INSEA) News* (1): 14–15.

Stuhr, P., Petrovich-Mwaniki, L., and Wasson, R. 1992. Curriculum guidelines for the multicultural classroom. *Art Education* 45(1): 16–24.

Sully, J. 1895. Studies of childhood, 15: The child as artist. *Popular Science* 48: 385–395.

Sumner, W. G. 1906. *Folkways.* New York: Ginn.

Tiedt, P. L., and Tiedt, I. M. 1990. *Multicultural teaching: A handbook of activities, information, and resources.* Boston: Allyn & Bacon.

Tomhave, R. D. 1992. Value bases underlying conceptions of multicultural education: An analysis of selected literature in art education. *Studies in Art Education* 34(1): 48–60.

Triandis, H. C. 1983. Essentials of studying cultures. In D. Landis and R. W. Brislin (eds.), *Handbook of intercultural training: Vol. 1. Issues of theory and design.* New York: Pergamon.

Tricarico, D. 1991. Guido: Fashioning an Italian-American youth style. *Journal of Ethnic Studies* 19(1): 41–66.

Vasquez, A. 1973. *Art and society: Essays in Marxist aesthetics.* London: Merlin.

Wasson, R. F., Stuhr, P. L., and Petrovich-Mwaniki, L. 1990. Teaching art in the multicultural classroom: Six position statements. *Studies in Art Education* 31(4): 234–246.

Wilson, B. In press. *The quiet evolution: Implementing discipline-based art education in six regional professional development consortia.* Santa Monica, CA: Getty Center for Education in the Arts.

Wolff, J. 1981. *The social production of art.* London: Macmillan.

Young, B. (ed.). 1990. *Art, culture, and ethnicity.* Reston, VA: National Art Education Association.

Zerffi, G. G. 1876. *A manual of the historical development of art.* London: Hardwicke & Boque.

Zimmerman, E. 1990a. Preparing to teach art to secondary students from all cultural backgrounds. In B. Little (ed.), *Secondary art eduction: An anthology of issues.* Reston, VA: National Art Education Association.

Zimmerman, E. 1990b. Questions about multiculture and art education or I'll never forget the day M'Blawi stumbled on the work of the post-impressionists. *Art Education* 43(6): 8–24.

Zimmerman, E. 1990c. Teaching art from a global perspective. *ERIC Art* (December).

Zimmerman, E., and Clark, G. 1992. *Resources for teaching art from a multicultural point of view* (ERIC Digest). Bloomington, IN: ERIC:ART.

Zurmuehlen, M. 1990. *Studio art: Praxis, symbol, presence.* Reston, VA: National Art Education Association.

F. Graeme Chalmers

F. Graeme Chalmers is professor of art education at the University of British Columbia, Vancouver, Canada. He graduated from art school, received his initial teacher education, and taught secondary school art in Aotearoa, New Zealand. As a Fulbright grantee, he came to the United States in 1968 and completed graduate degrees at Indiana University and at the University of Oregon, where his mentor was June K. McFee. He has subsequently published extensively on various aspects of art, culture, and education. His interest in cross-cultural art education has been nourished by his terms as chief examiner in art/design for the International Baccalaureate Organization and as a vice president of the International Society for Education through Art. He is a distinguished fellow of the National Art Education Association, and has won the U.S. Society for Education through Art's Edwin Ziegfeld Award for distinguished international leadership in art education.

Designer: Eileen Delson
Cover Illustration: Roland Young
Production Coordinator: Amy Armstrong
Illustration Coordinator: Adrienne Lee
Copy Editor: Judy Selhorst
Managing Editor: Kathy Talley-Jones